Art Nouveau Designs

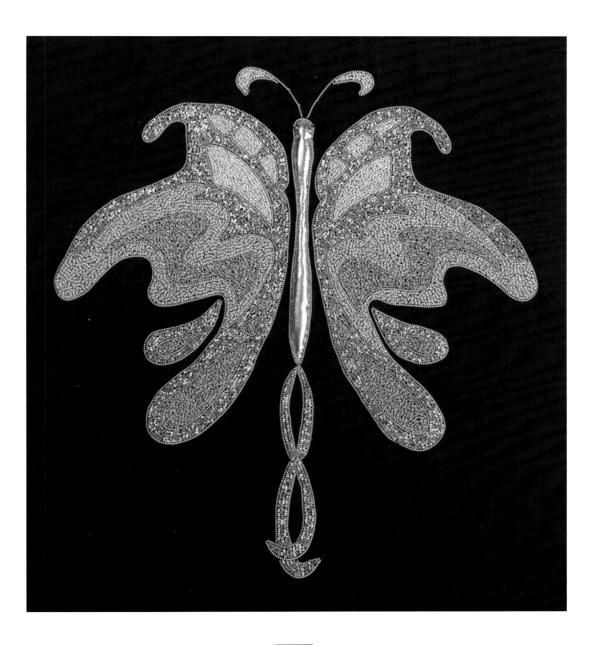

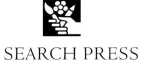

SEARCH PRESS

First published in Great Britain 2008 by

Search Press Limited
Wellwood
North Farm Road
Tunbridge Wells
Kent TN2 3DR

Text copyright © Search Press 2008
Photographs by Search Press Studios and Roddy
Paine Photographic Studios

Photographs and design copyright ©
Search Press Ltd. 2008

ISBN 13: 978-1-84448-300-6

Art Nouveau Designs is a compendium volume of
illustrations taken from the Design Source Books:
*Art Nouveau Designs, Art Nouveau Borders
& Motifs* and *Art Nouveau Flowers*. The
photograph on page 5 is taken from *Classic Glass
Painting*; the photographs on pages 10, 12–15 are
taken from *Handmade Art Nouveau Cards*.

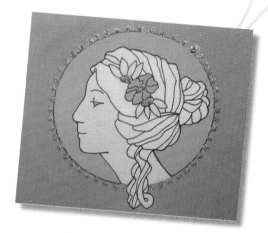

Page 1
Golden Butterfly
By Della Barrow
Design, see page 46

*Hollow metals and traditional goldwork
techniques are used to create this beautiful
embroidery. The image is outlined first, then
other areas filled in with the metals cut to
the size of small seed beads. Each piece is
threaded on and sewn down in sequence.
The body is slightly padded with felt and
covered with gold kid.*

Page 3
Jewelled Box
By Judy Balchin
Design, see page 31

*A beautiful box can be used to hold secret
treasures. Here, a plain embossed papier mache
box is painted with acrylic colour, then sponged
with gold paint to accentuate the raised pattern.
The Art Nouveau design is photocopied, painted
and glued to the top of the lid. Small gems are
used as decoration between the embossed
patterns, then an organza ribbon is wrapped
around the box and tied in a bow.*

Contents

Introduction

The Art Nouveau period lasted from 1880 to 1915 and during this time artists and craftspeople created a wonderful collection of designs using organic and ornamental shapes in a flowing harmony of line and symmetry. We are left with a legacy of beautiful work that still inspires us today. Simple or more elaborate and decorative, these Art Nouveau designs are instantly recognisable with their smooth curves and intertwining elements.

With over two hundred and fifty line illustrations, this book is packed with ideas that can be used to create a whole range of decorative projects. Here you will discover simple and ornate borders, stylised flowers, beautiful birds and butterflies, figures, fruit and much more. You do not need artistic skills, just photocopy or trace the motifs, pictures and patterns, then transfer them on to your project pieces. You will soon discover how easy it is to make unique designs for yourself, or friends and family.

The first section of the book offers some different ideas and includes an embroidered butterfly by Della Barrow and a selection of craft projects by designer Judy Balchin. Their chosen illustrations have been transferred on to different surfaces and used to decorate cards, boxes, panels, a bookmark and a cushion. The techniques vary from simple colouring and layering to glass painting, parchment craft and embossing. Full instructions are not given for any of these items; they have been included to inspire you and to show what can be achieved. However, if you do feel tempted to create any of them, we offer a full range of technique books on our website: www.searchpress.com.

As your confidence and skills grow, you will soon discover how enjoyable it is to develop the designs in your own way using your favourite techniques. Have fun.

The Search Press Team

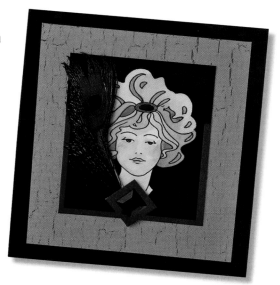

Tiffany Window Panel
By Judy Balchin

Design, see page 20

This design, inspired by the glorious works of Tiffany, is ideal for a glass painted panel. The glowing colours enhance the simplicity of the the quiet river scene. Self adhesive lead is used as a border to give an antique look and the colour blending technique on the leaves and flowers brings life to the whole design.

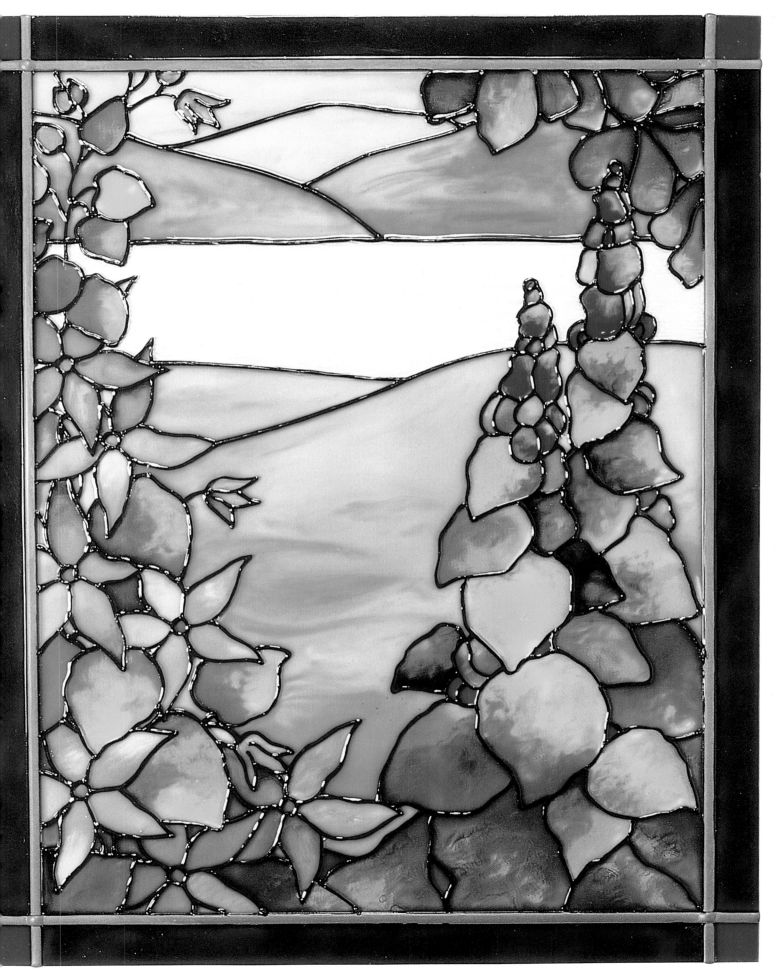

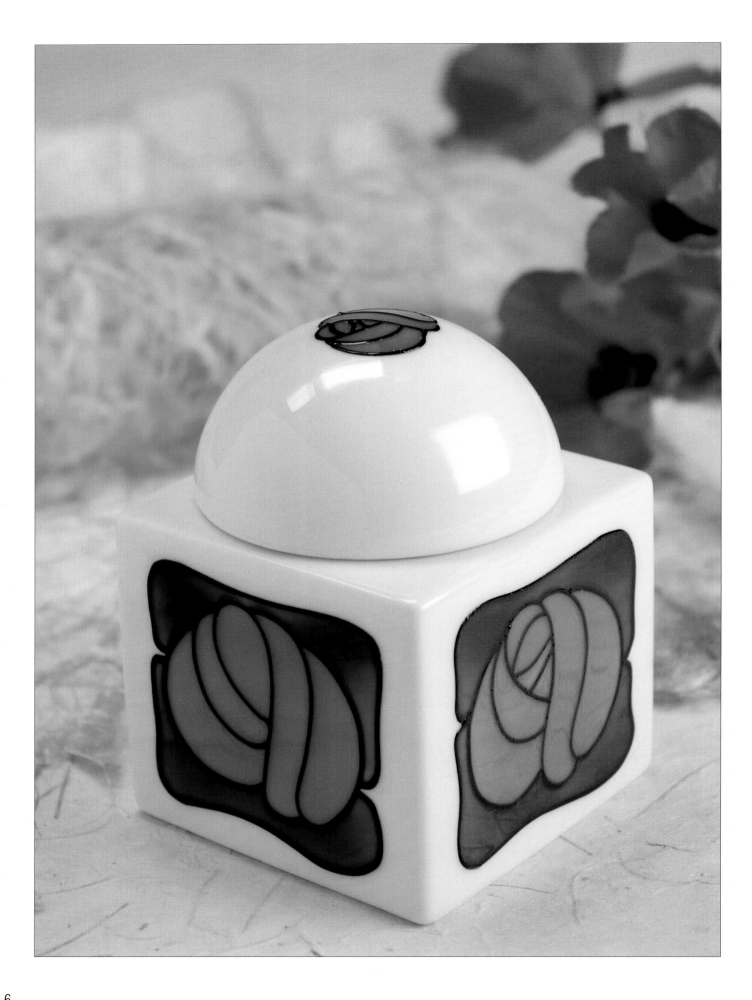

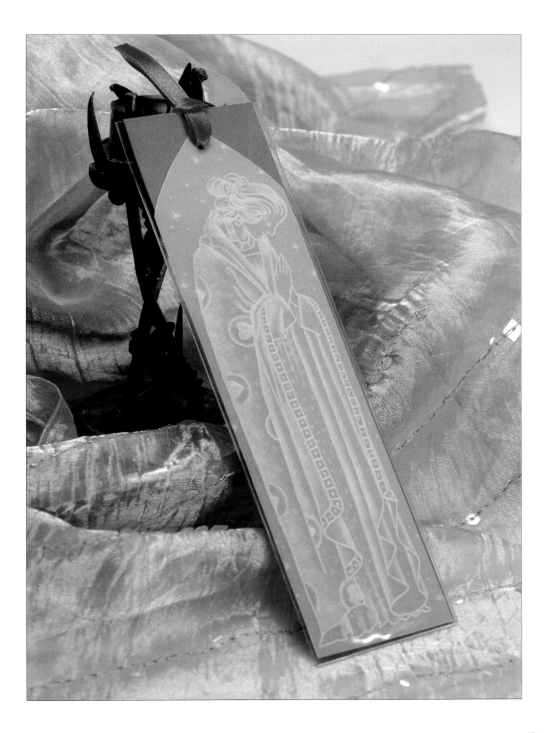

Opposite:

Rose Pot

By Judy Balchin

Design, see page 55

This flat-sided ceramic container offers an ideal surface for a simple design. The rose and leaf motif is transferred on to each side of the pot using carbon paper. The rose design is then reduced on a photocopier and transferred on to the lid. Ceramic paints are used to outline and colour the leaves and flowers. When dry, the pot is baked in the oven. This hardens the paints and makes them durable.

Bookmark

By Judy Balchin

Design, see page 40

Bookmarks are an ideal gift and this design of a serene woman in flowing robes is perfect for such a project. Using parchment craft techniques, the image is traced on to parchment paper and the gown is then shaded and decorated with embossed hearts. The whole design is cut out, backed with red card and slipped into a transparent sleeve. A matching silk ribbon is threaded through a punched hole at the top of the bookmark.

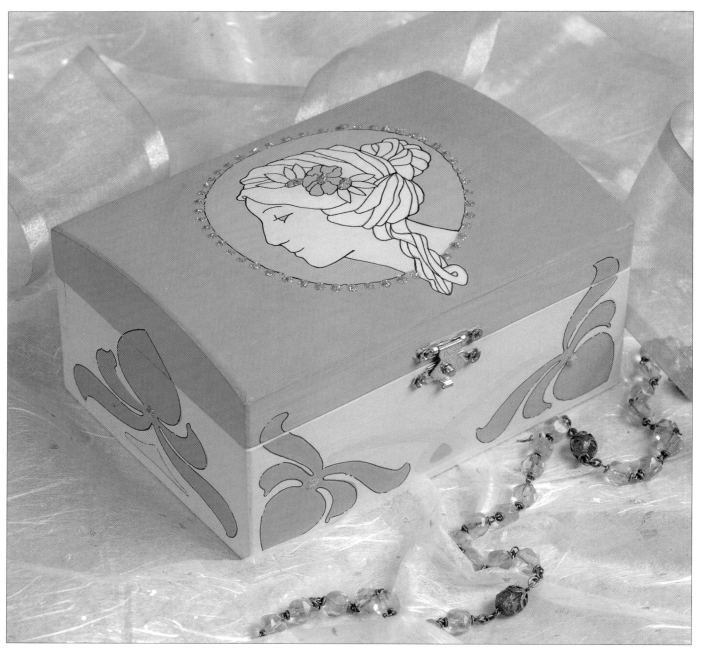

Jewellery Box

By Judy Balchin

Designs, see pages 42 and 53

A beautiful Art Nouveau portrait is the main design, complementing the smooth curves of the box lid. Decorative leaves adorn the four sides of the base. A limited palette of muted matt acrylic paints is used to transform the plain wooden surface of the box and when the colours are dry, the designs are transferred using transfer paper. They are then painted and outlined with a permanent marker pen. Finally, the lid design is edged with a row of irridescent glitter glue dots.

Opposite:

Iris Card

By Judy Balchin

Design, see page 27

Flowers feature frequently in Art Nouveau designs, particularly the iris and lily. I have chosen to use glass paints here because of their beautiful glowing colours. The flower is outlined on acetate, then painted with diluted colours to give a pastel and more sophisticated look. The design is then mounted on to card and decorated with lilac gems.

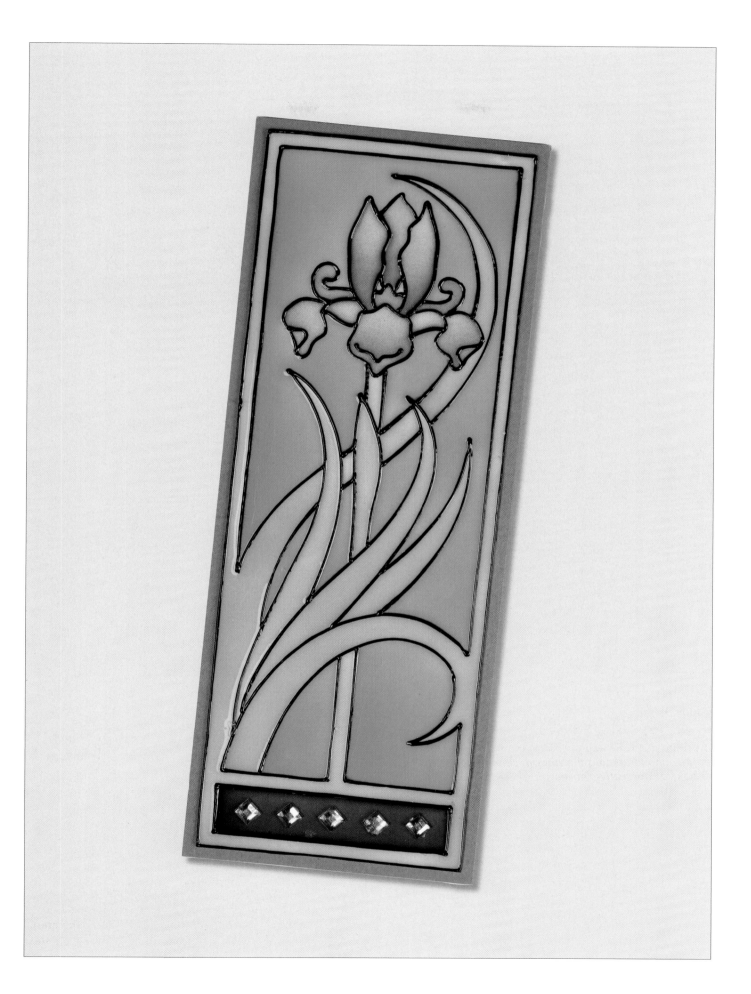

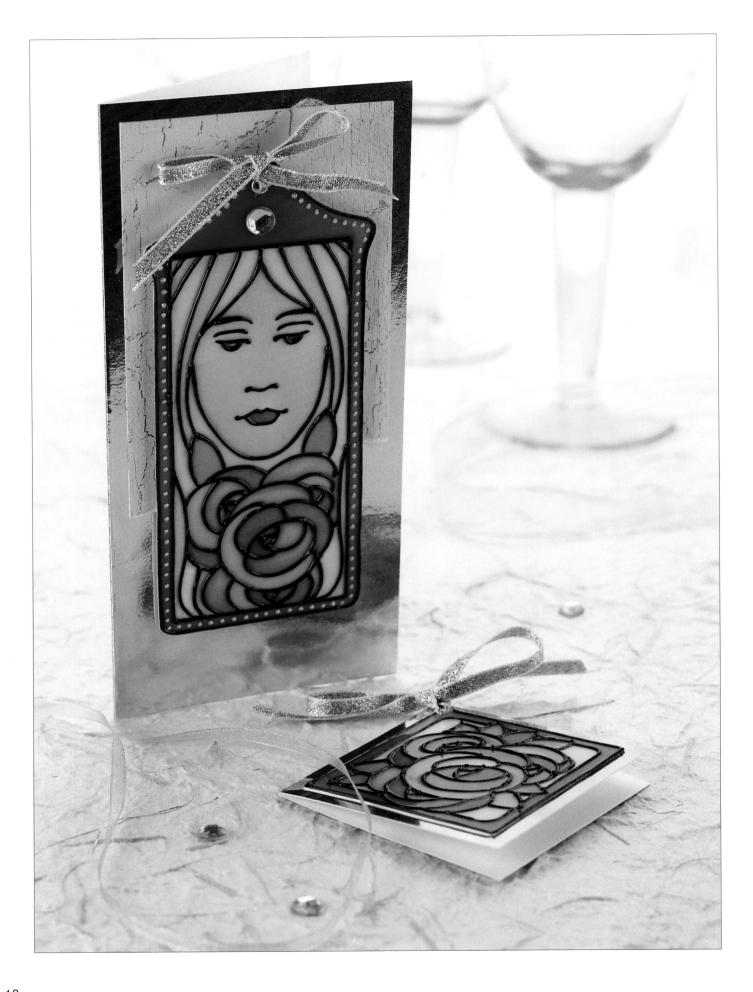

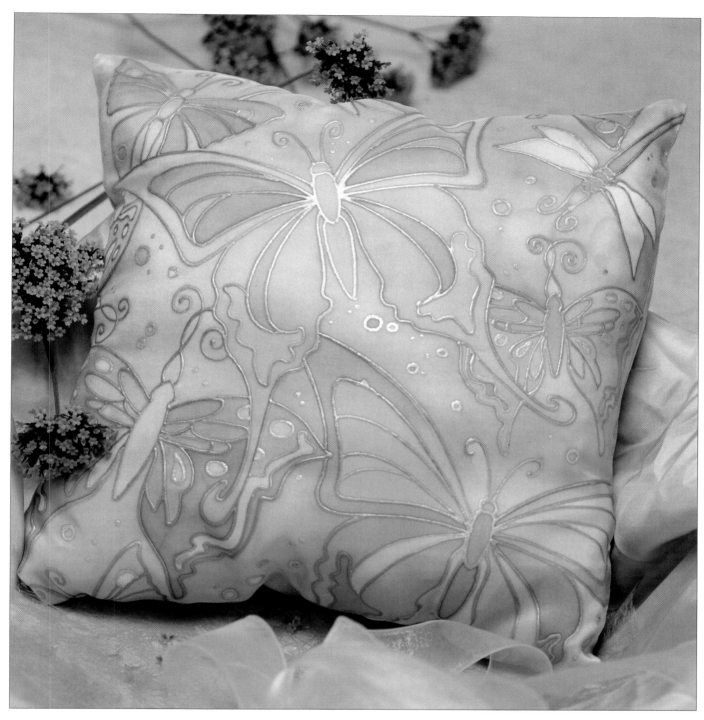

Scented Butterfly Cushion

By Judy Balchin

Design, see page 46

You will often find a butterfly or dragonfly dancing through Art Nouveau designs. They really do typify the style of this period with their delicate lines and natural beauty. Diluted silk paints are used here to give a soft look. The butterfly designs are transferred on to stretched silk, outlined with gold gutta and painted. When dry, the cushion cover is made and padded. The centre of the wadding is sprinkled with a little essential oil to give a sweet, lingering fragrance.

Opposite:

Flower Maiden

By Judy Balchin

Designs, see page 19

Art Nouveau figures are beautifully stylised with flowing, balanced lines and perfect symmetry. This design of a young flower maiden is just right for a special card and a gift tag. Glass paints are used on acetate, then the designs are cut out and layered on crackled cream background paper and gold card.

Seahorse

By Judy Balchin

Design, see page 48

This design is painted using gouache, which gives a flat, opaque finish. It is then mounted on to card and embellished with small spots of silver relief outliner.

Feather maiden

By Judy Balchin

Design, see page 52

The girl's face is painted with watercolour, cut out then mounted on layered card. The peacock feather and gem complete the design.

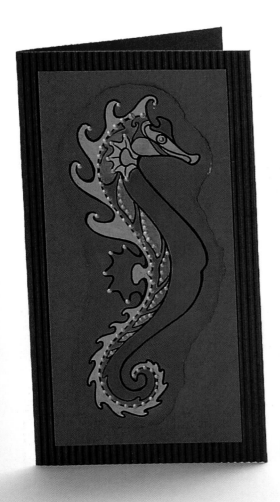

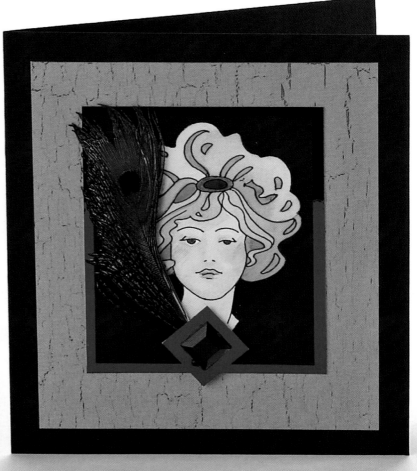

Ancient key

By Judy Balchin

Design, see page 60

Ornamental briar roses frame the central key which is hangs against a gold card background. The border flowers, stems and background are painted using watercolours and a beautiful bow completes the design.

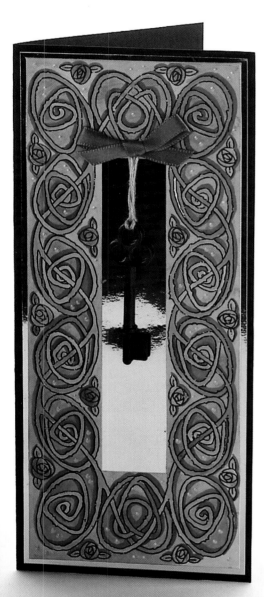

Beads and gems

By Judy Balchin

Design, see page 22

The circular design below is painted with watercolours and decorated with gems and dots of gold relief outliner. Matching beads and threads wrapped round the fold add a colourful finishing touch.

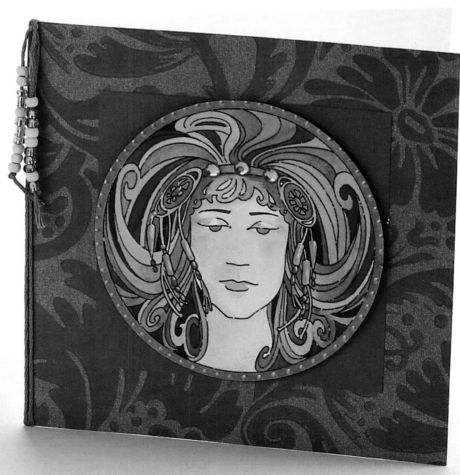

Silver Peacock

By Judy Balchin

Design, see page 35

The peacock is embossed on to silver embossing foil, cut out then backed with pastel floral background paper. The card is then decorated with lilac eyelets and brads to create a simple yet effective design. A single embossed feather is used to create a matching gift tag.

Grapevine

By Judy Balchin

Design, see page 17

Gold foil is embossed with a popular grape design, then the gate card is wrapped with cord and embellished with jewels.

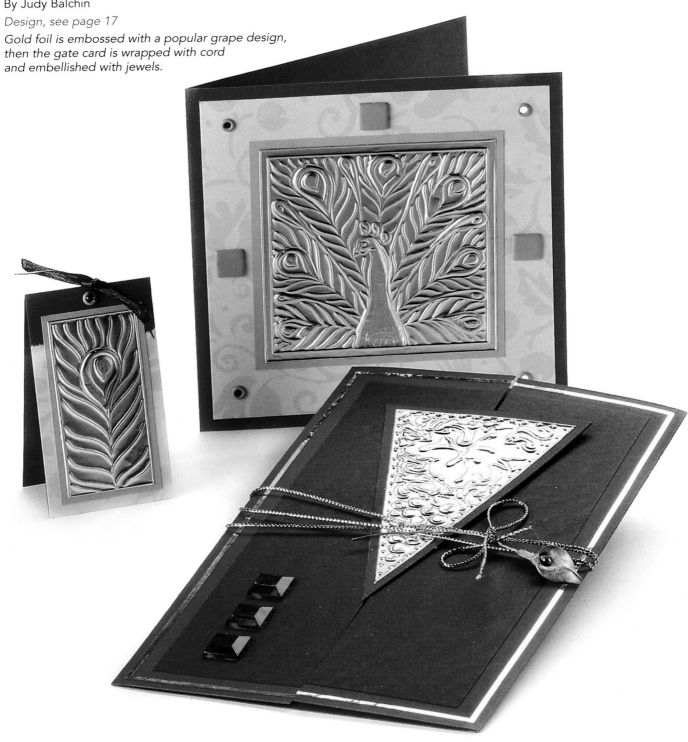

Roses

By Judy Balchin

Design, see page 35

The gold embossed roses are edged with black card and crackled cream paper, then mounted on to gold card. One rose is used on the matching gift tag.

Turquoise iris

By Judy Balchin

Design, see page 18

This popular design is embossed on turquoise foil which is cut out and glued to a gold card panel. Jewels and eyelets are added, then the panel is glued to a base card decorated with matching handmade paper and ribbon.

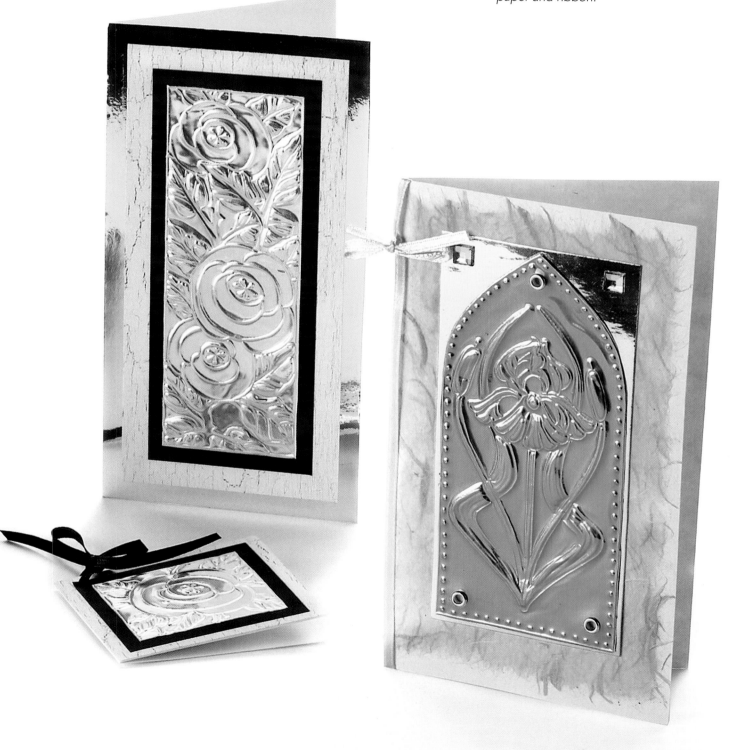

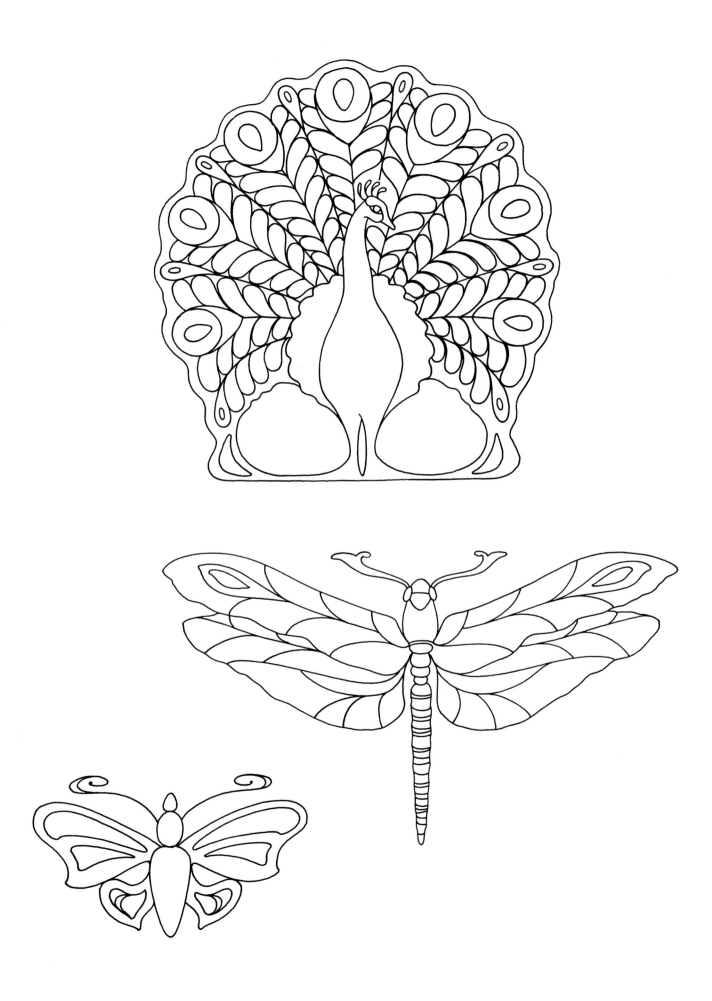

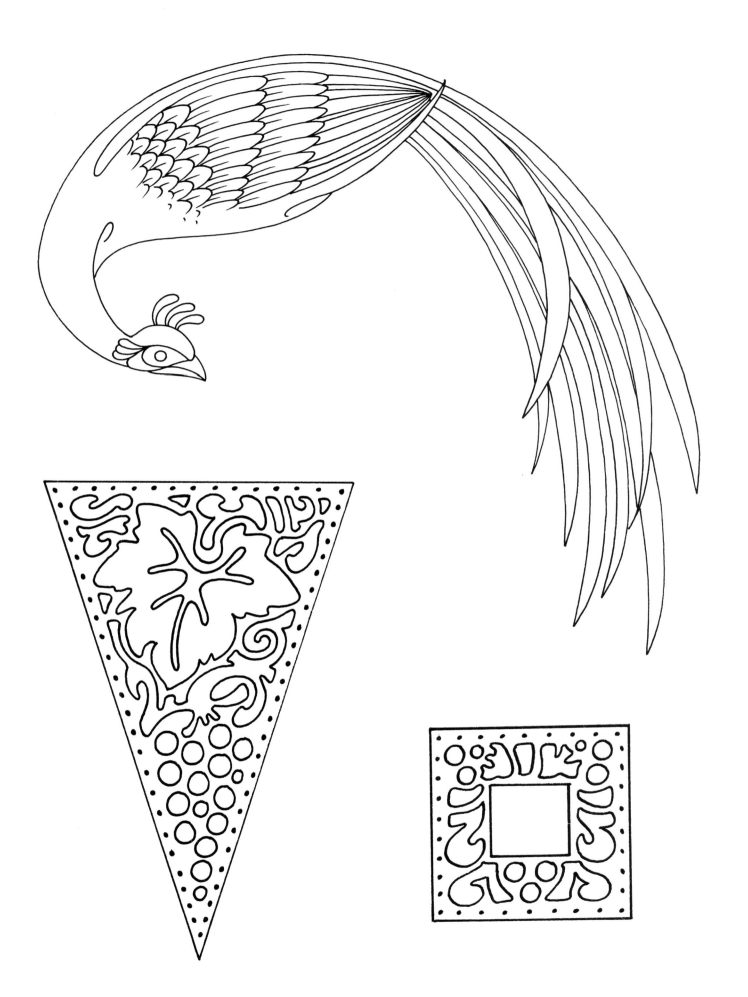

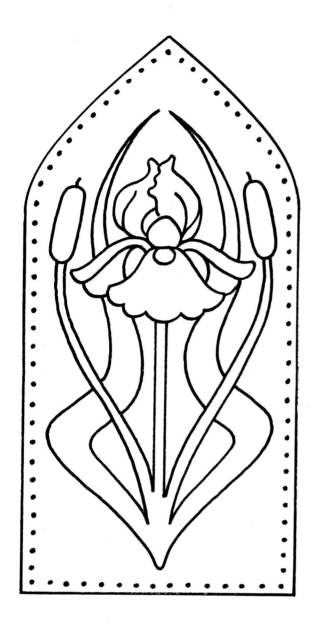
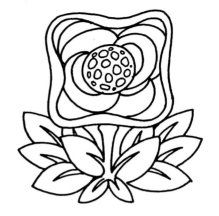
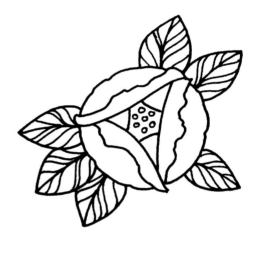

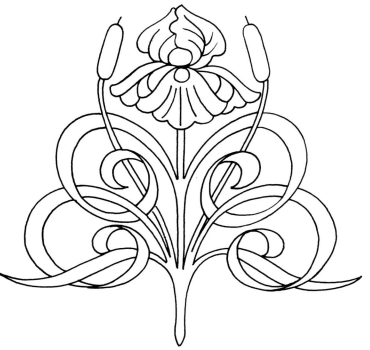

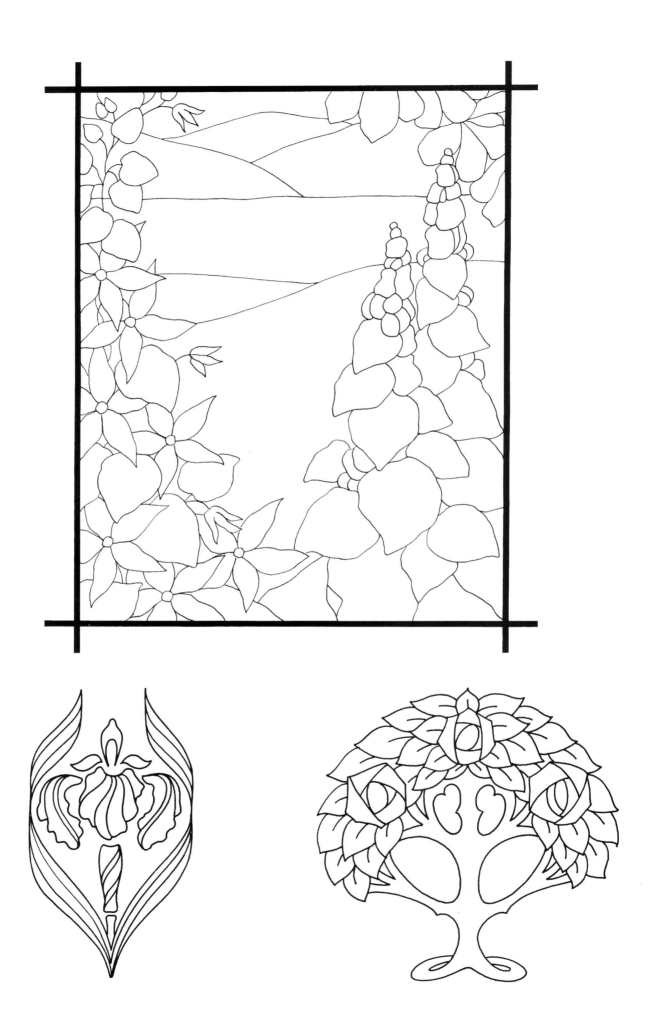

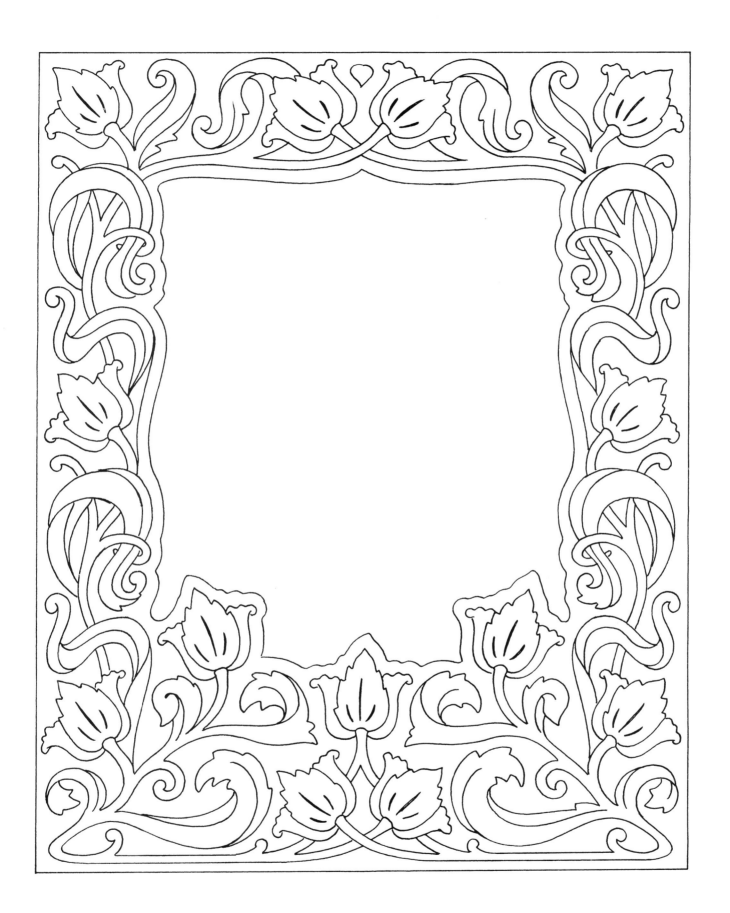

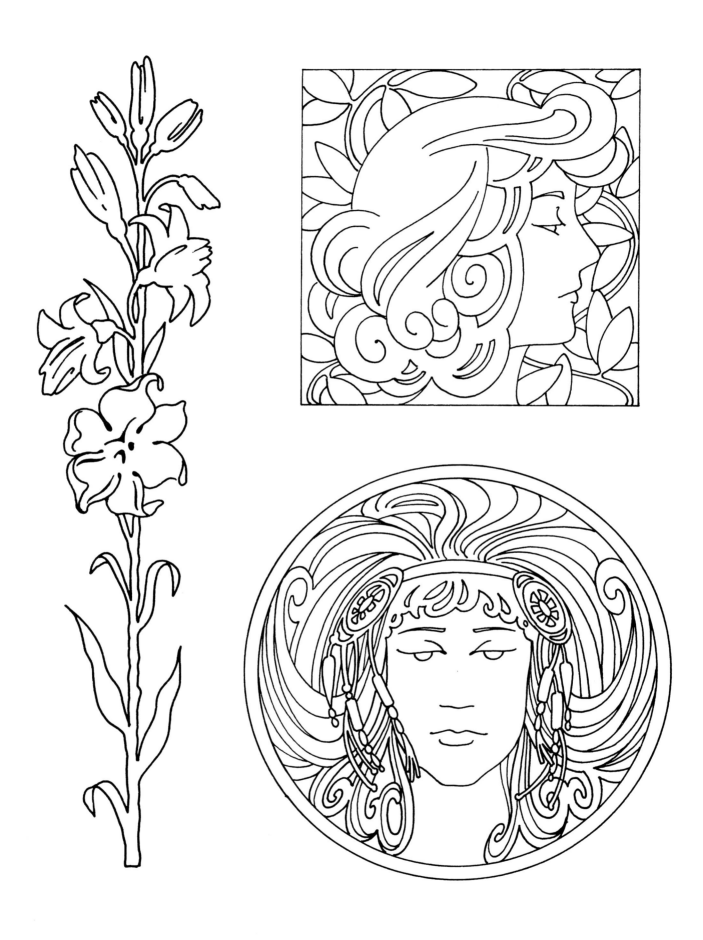

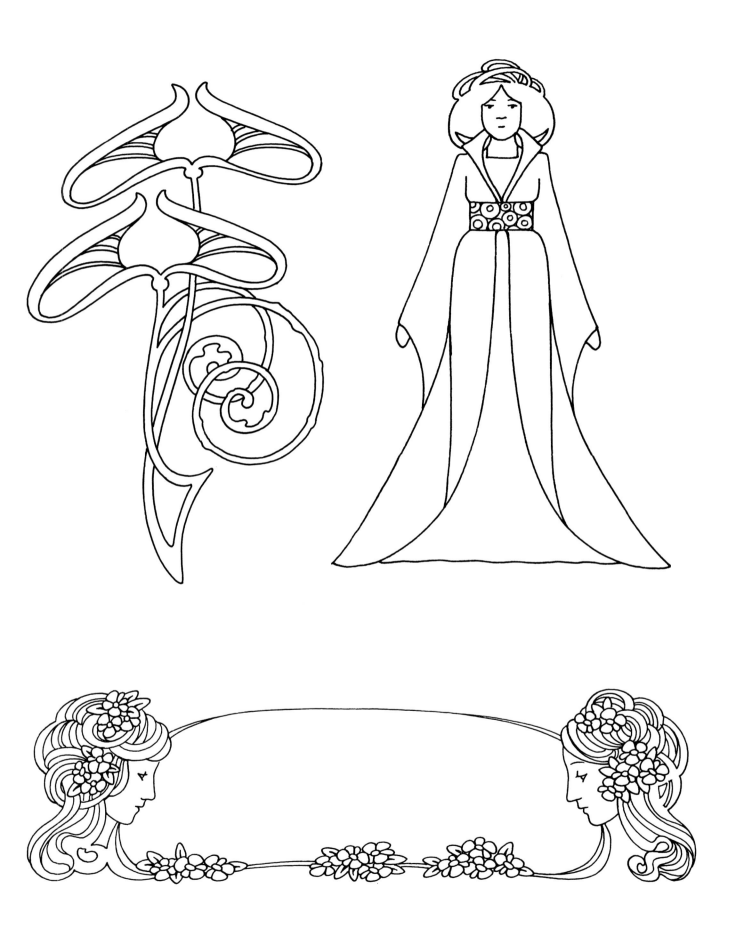

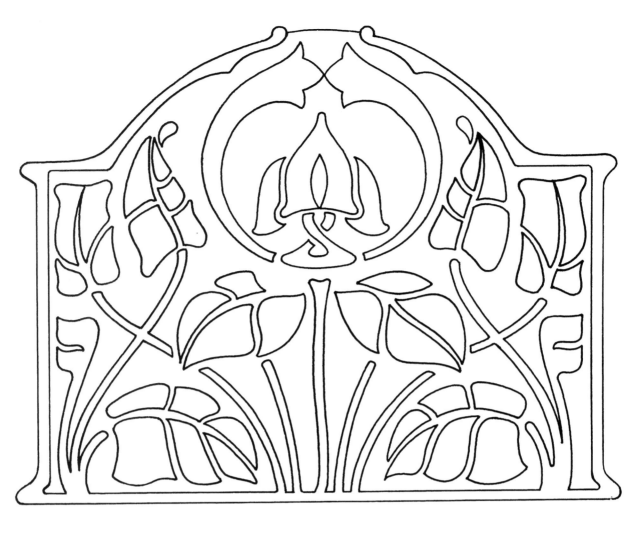

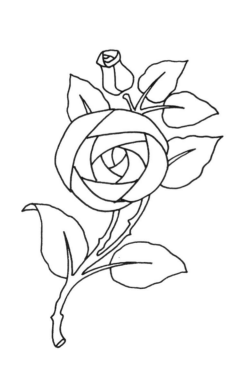

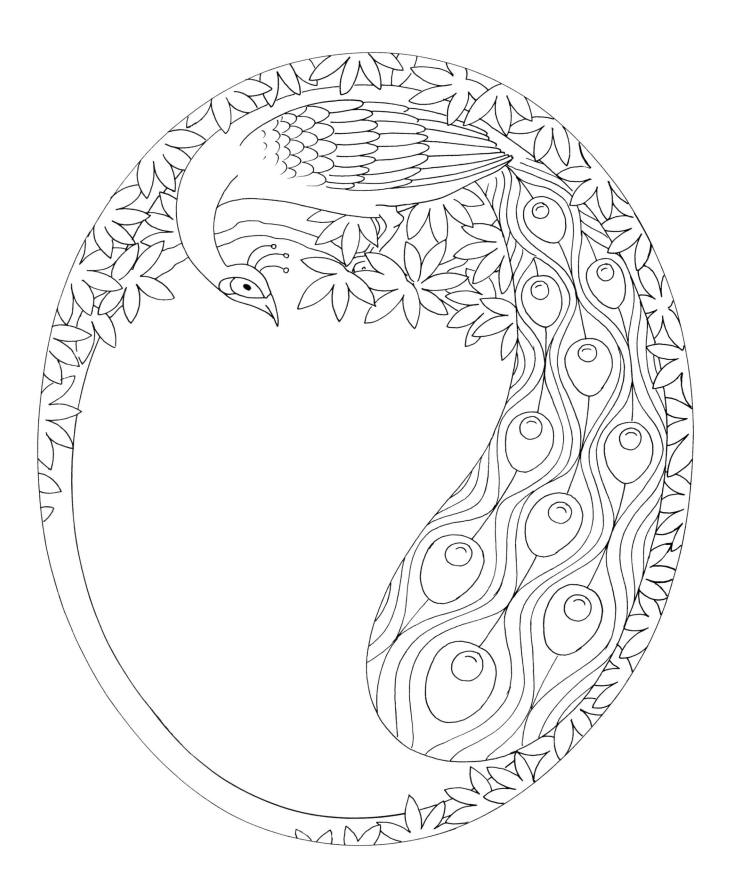

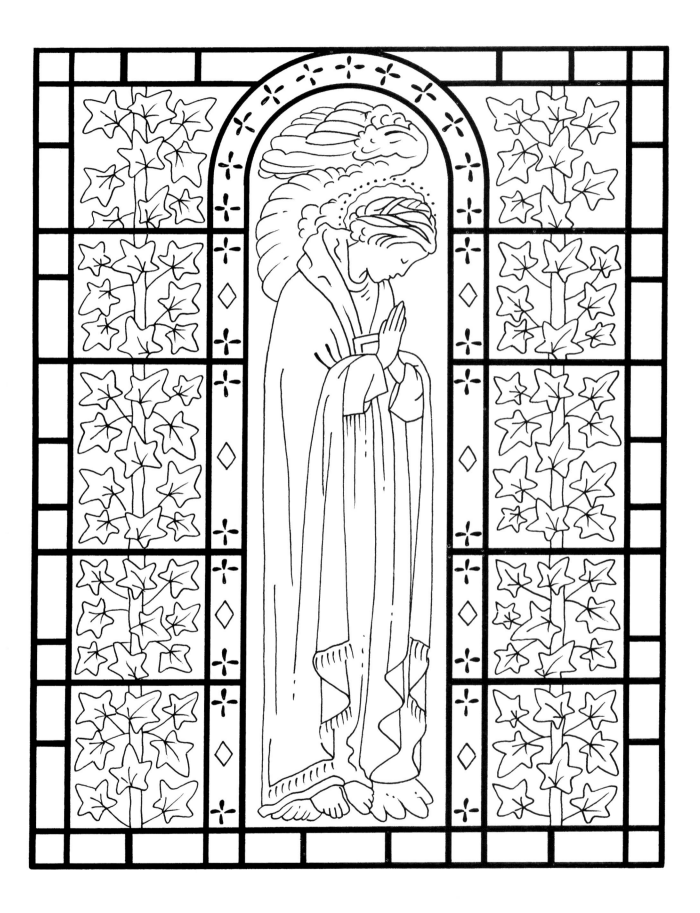

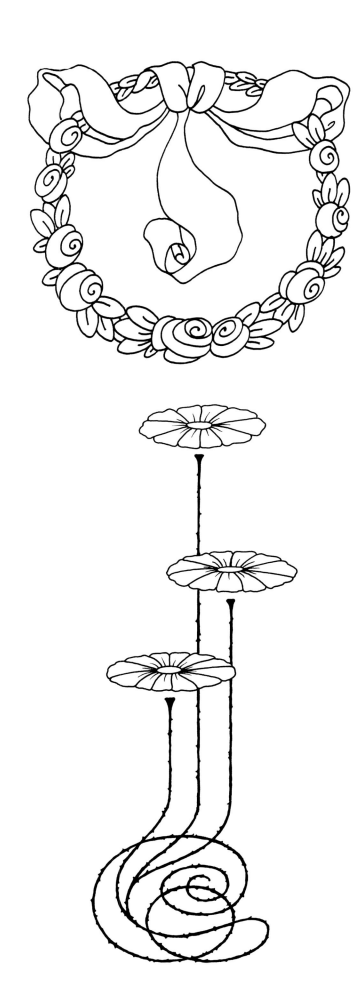

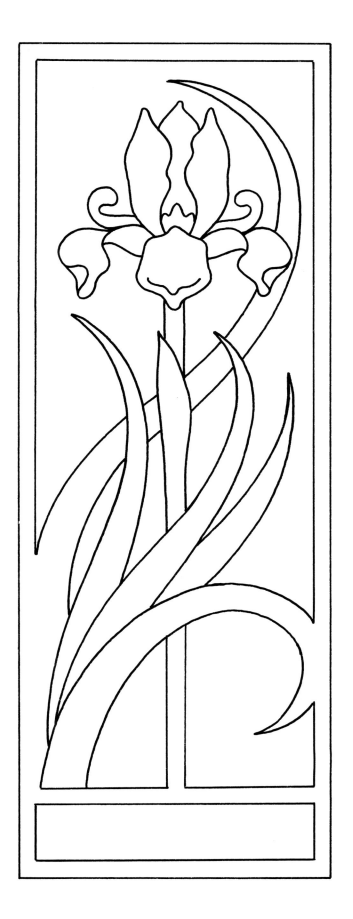

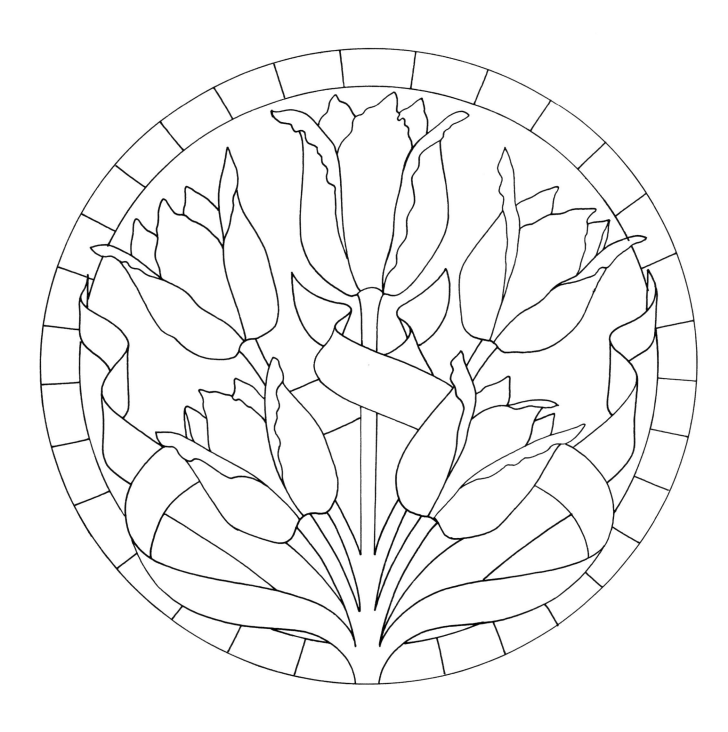

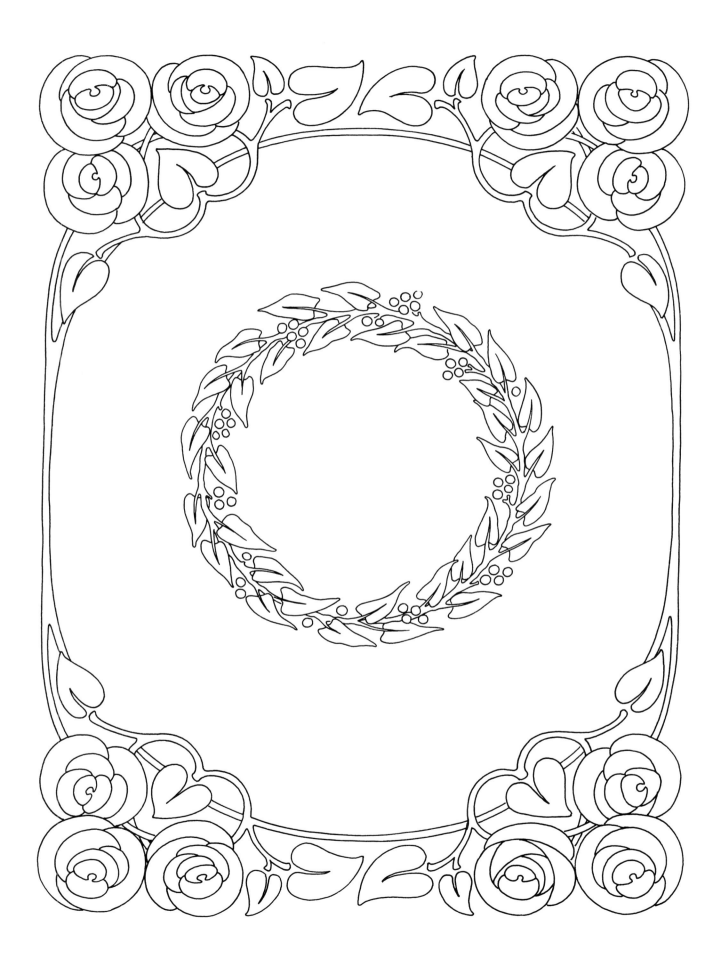

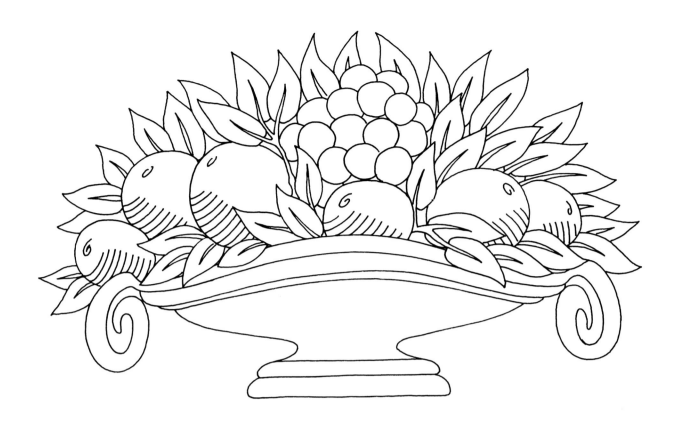

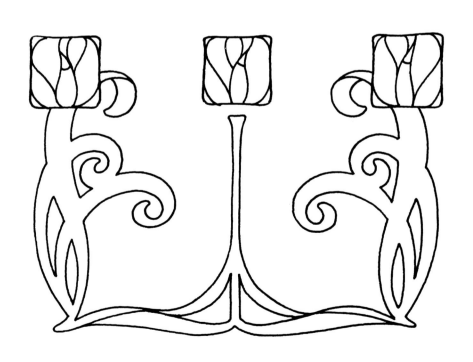

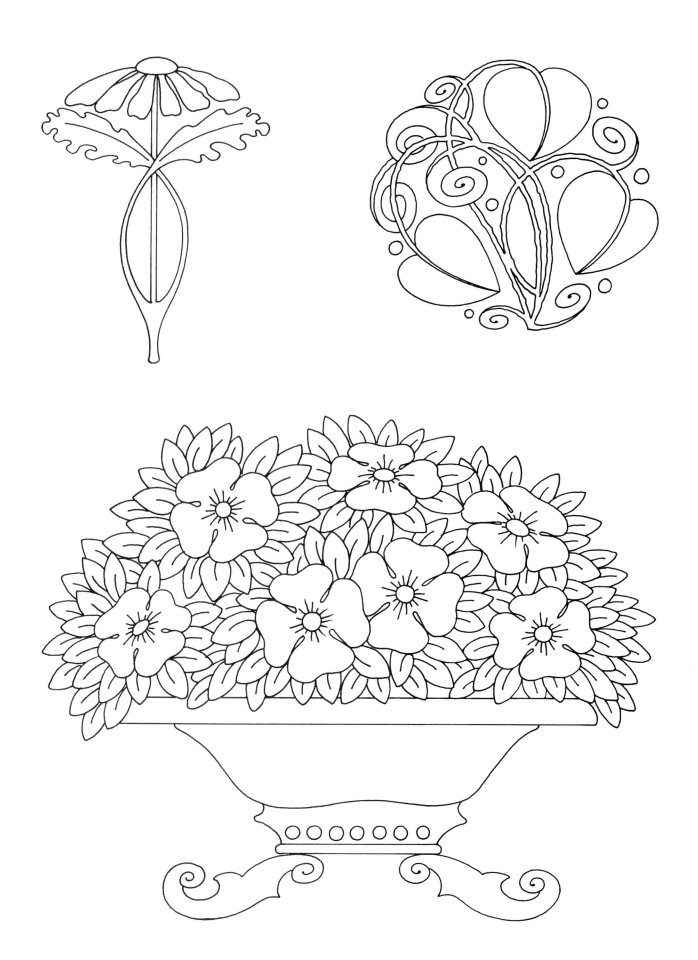

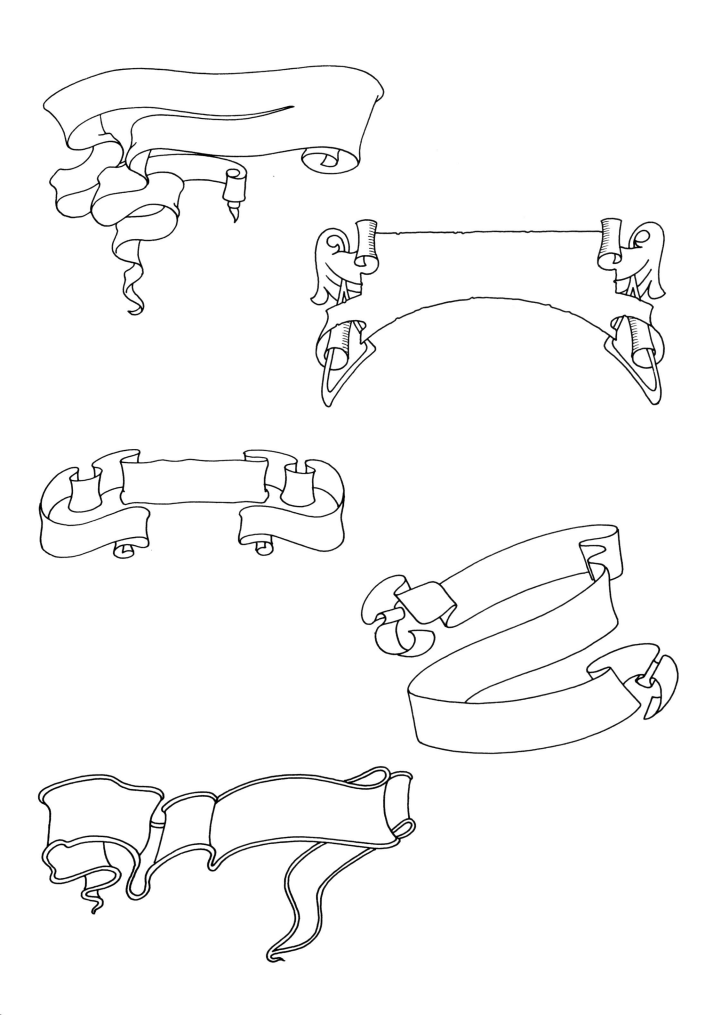

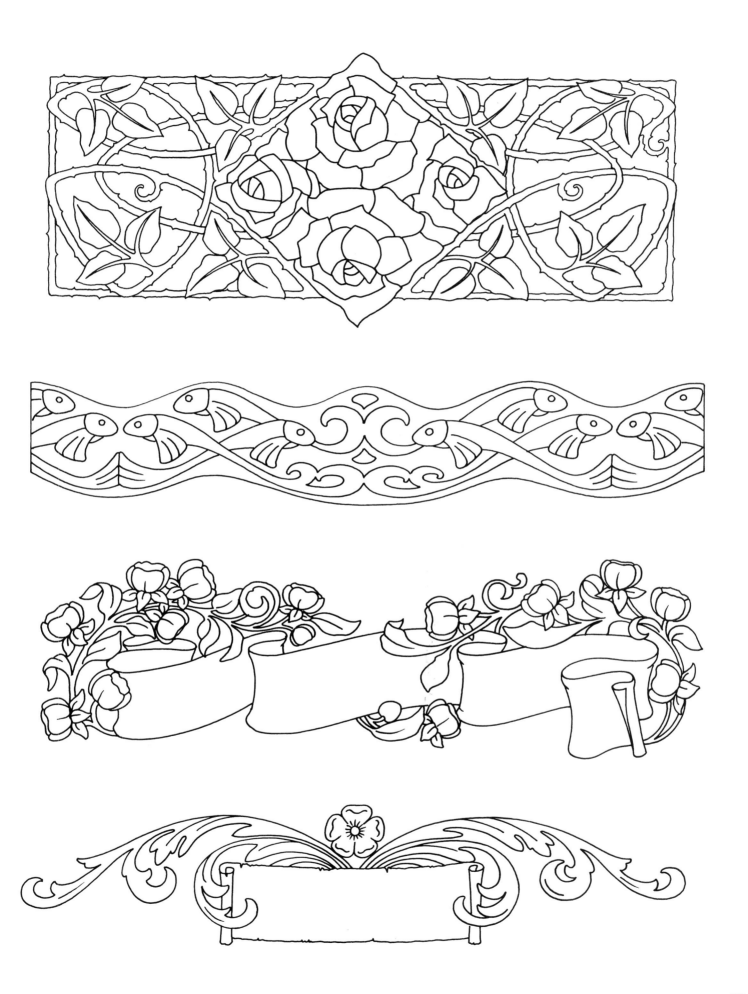

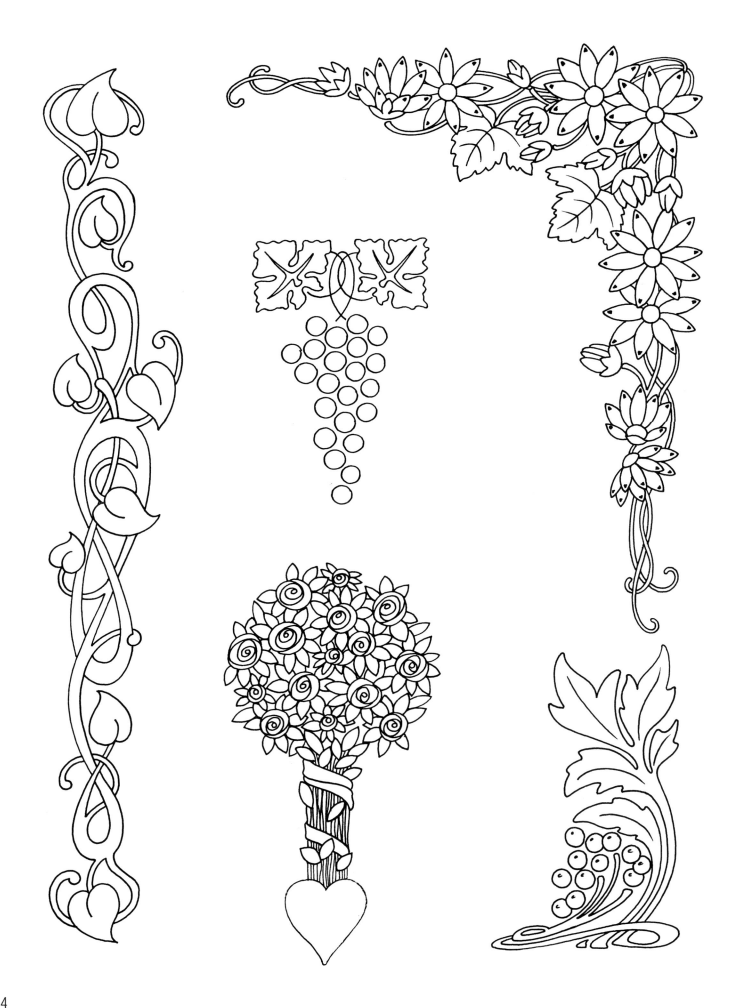

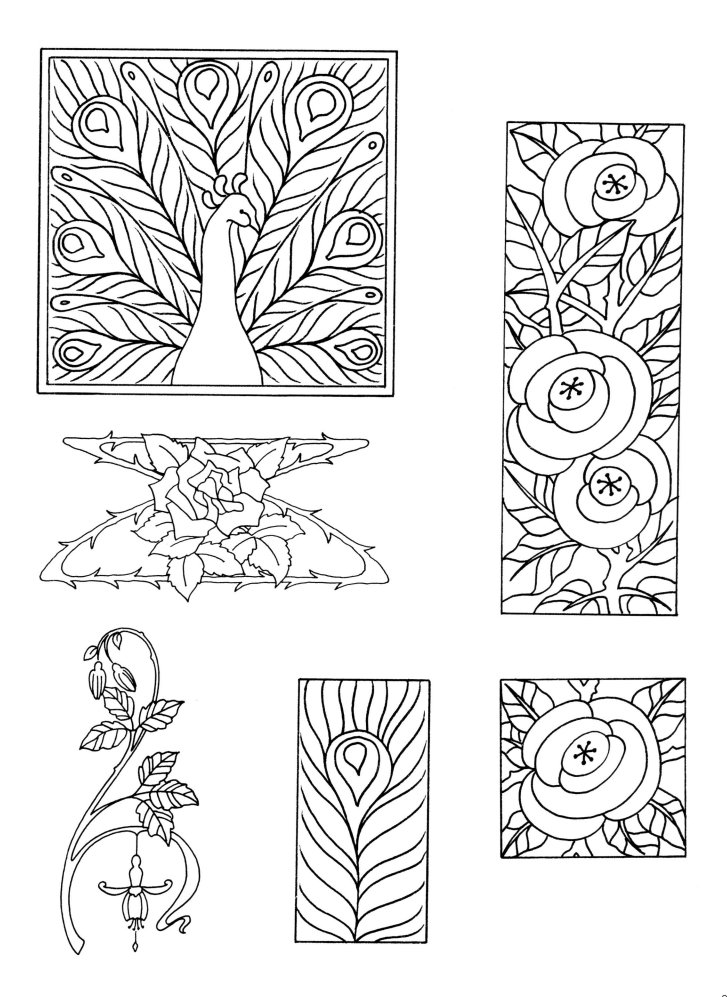

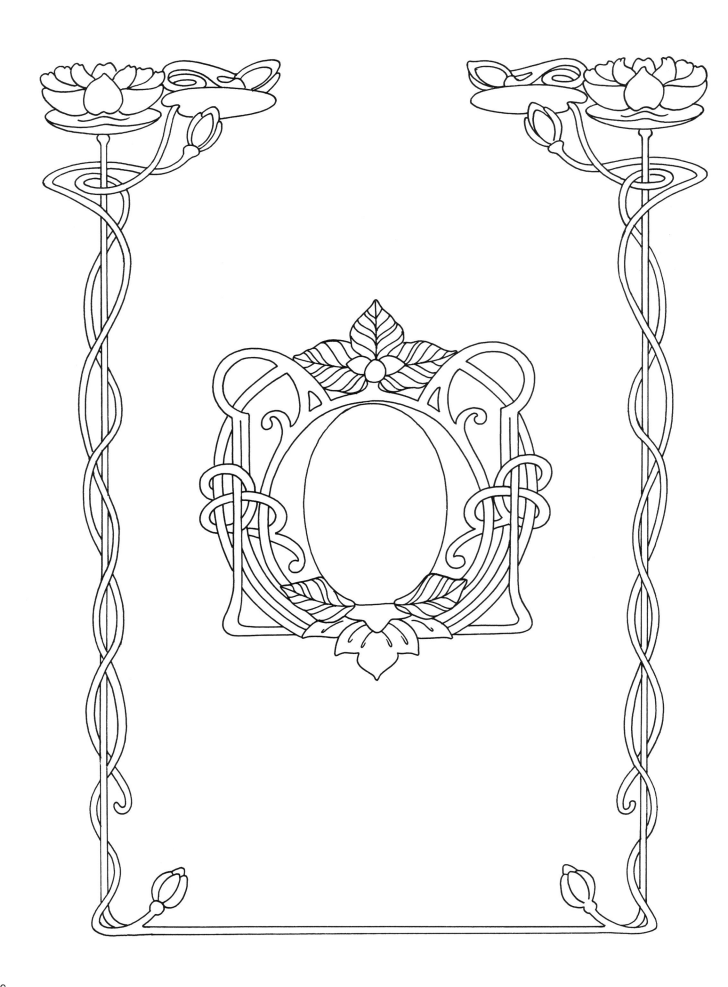

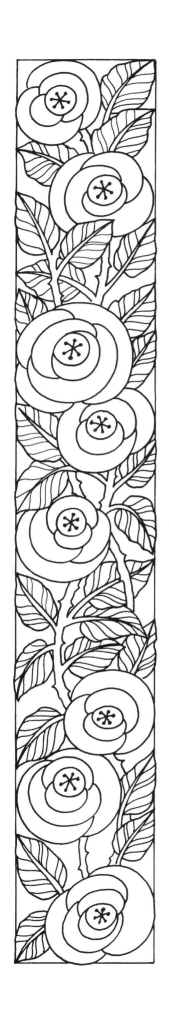

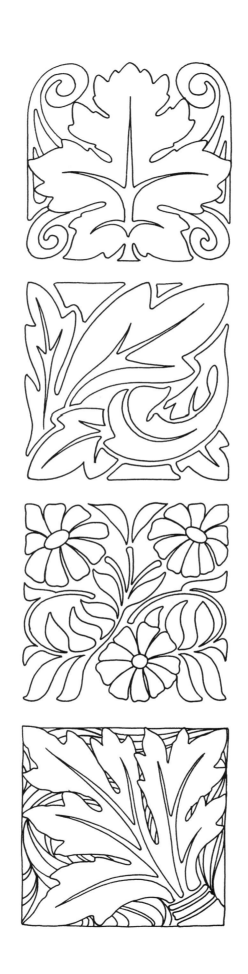

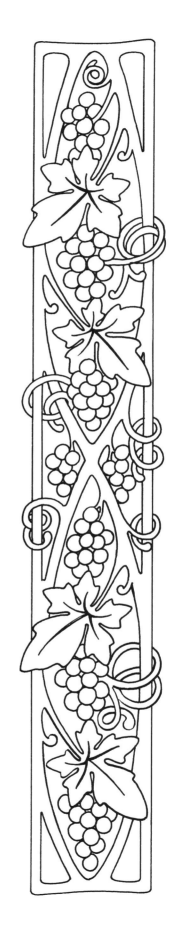

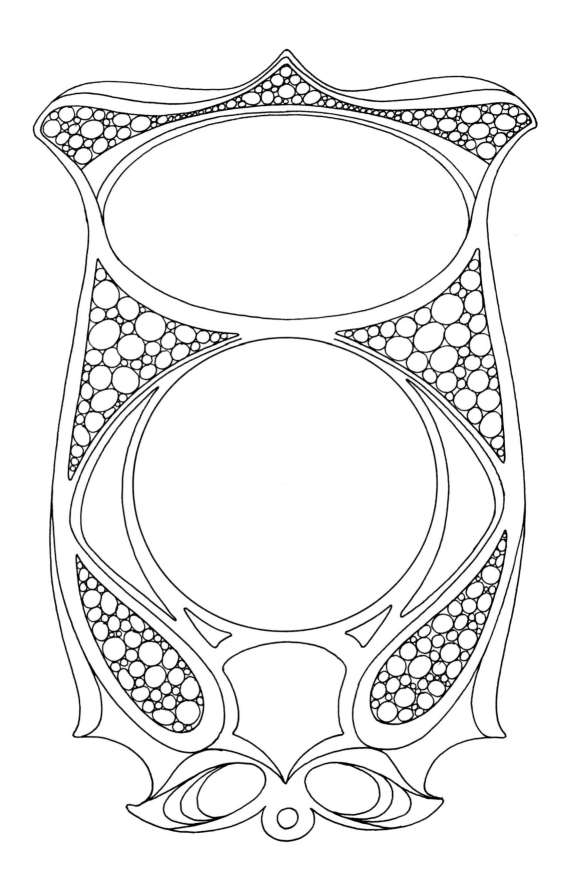

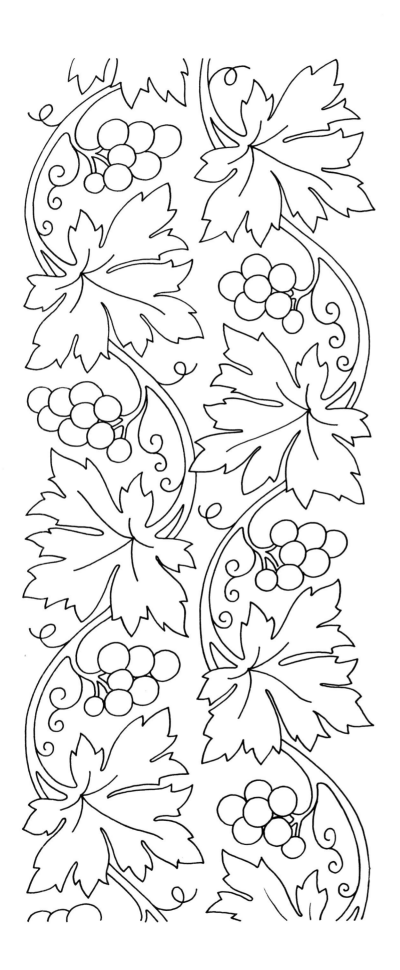

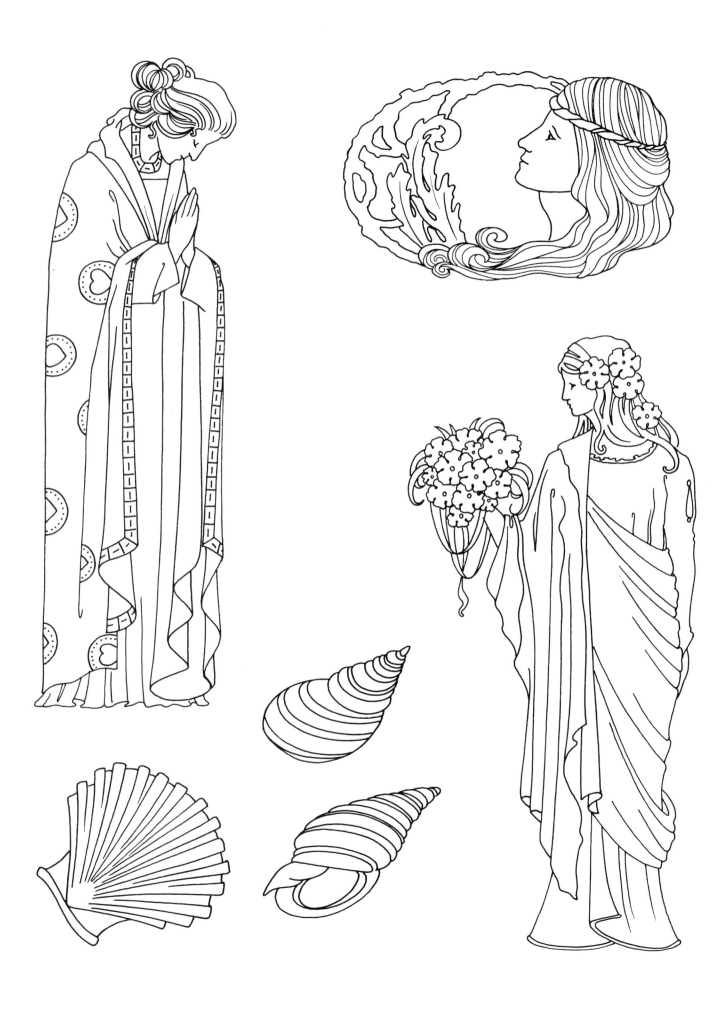

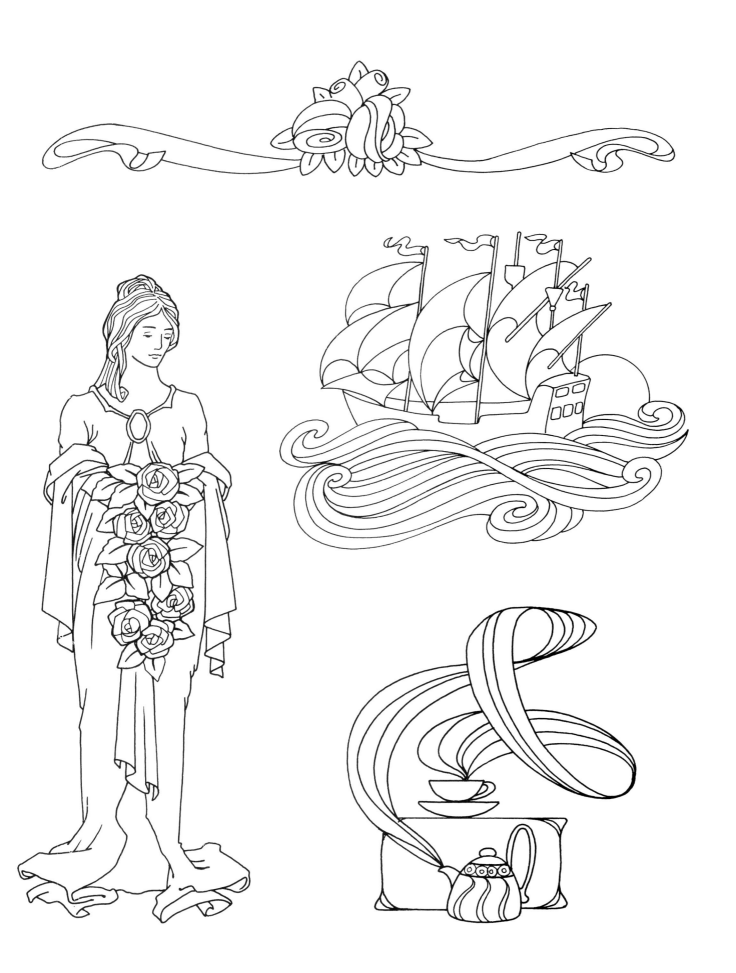

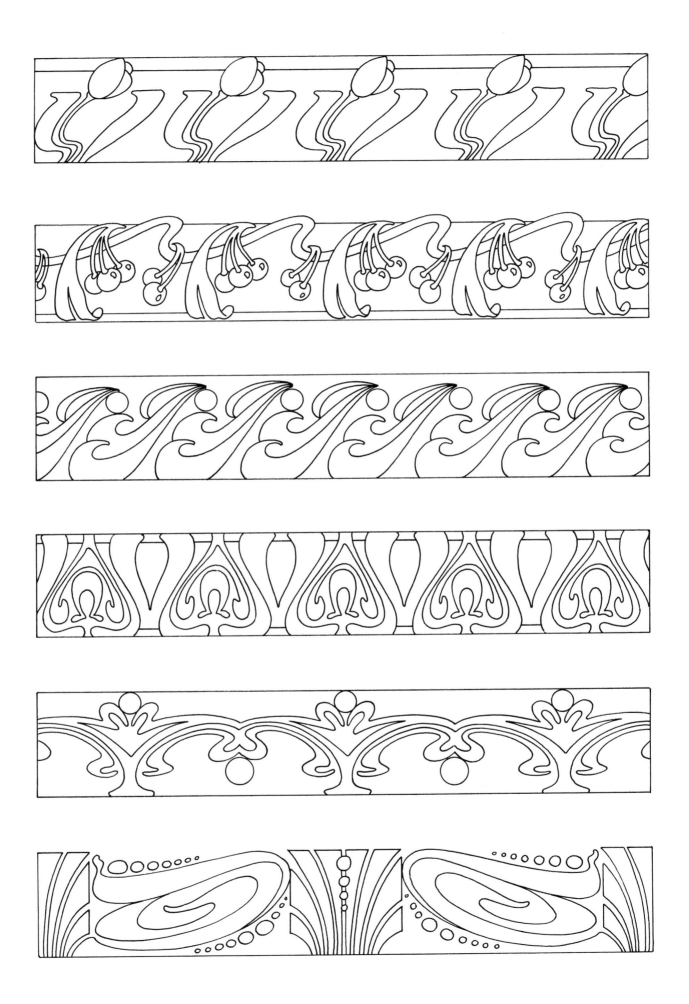

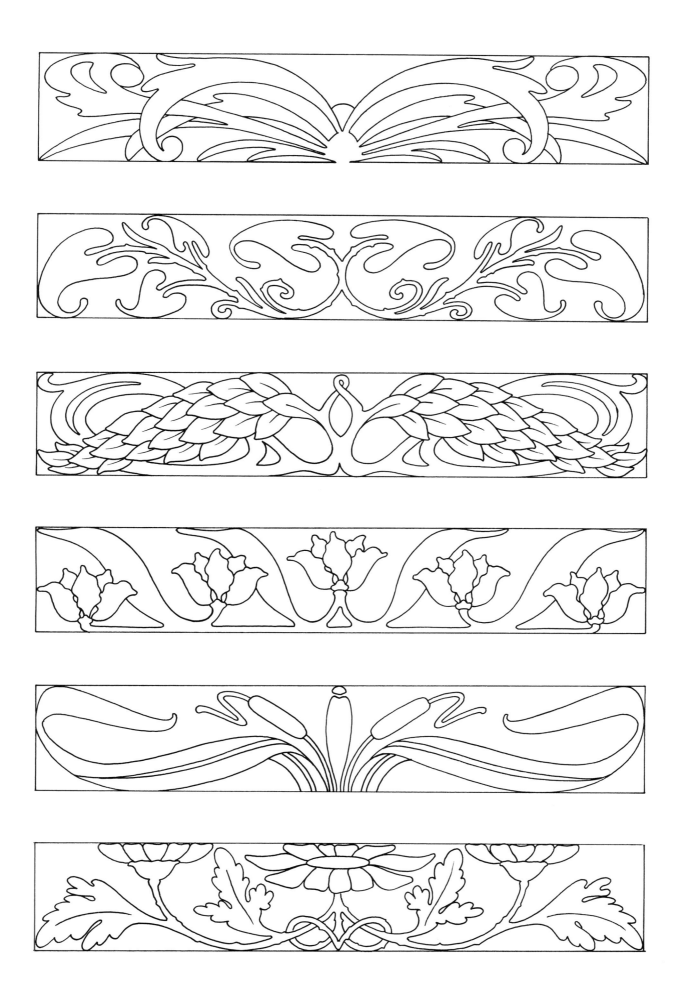

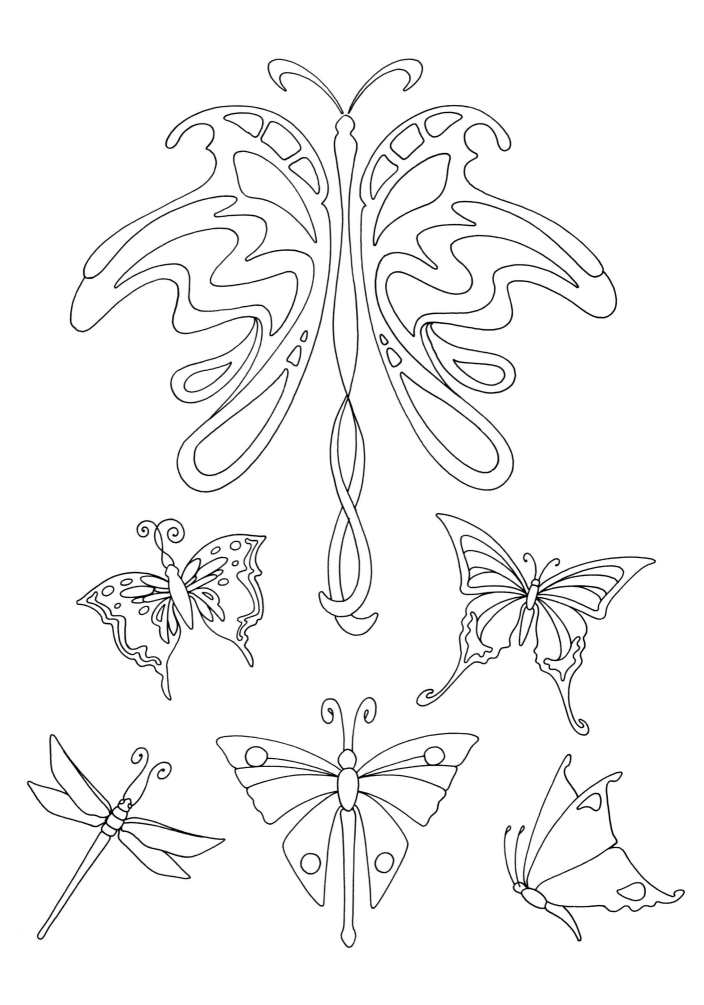

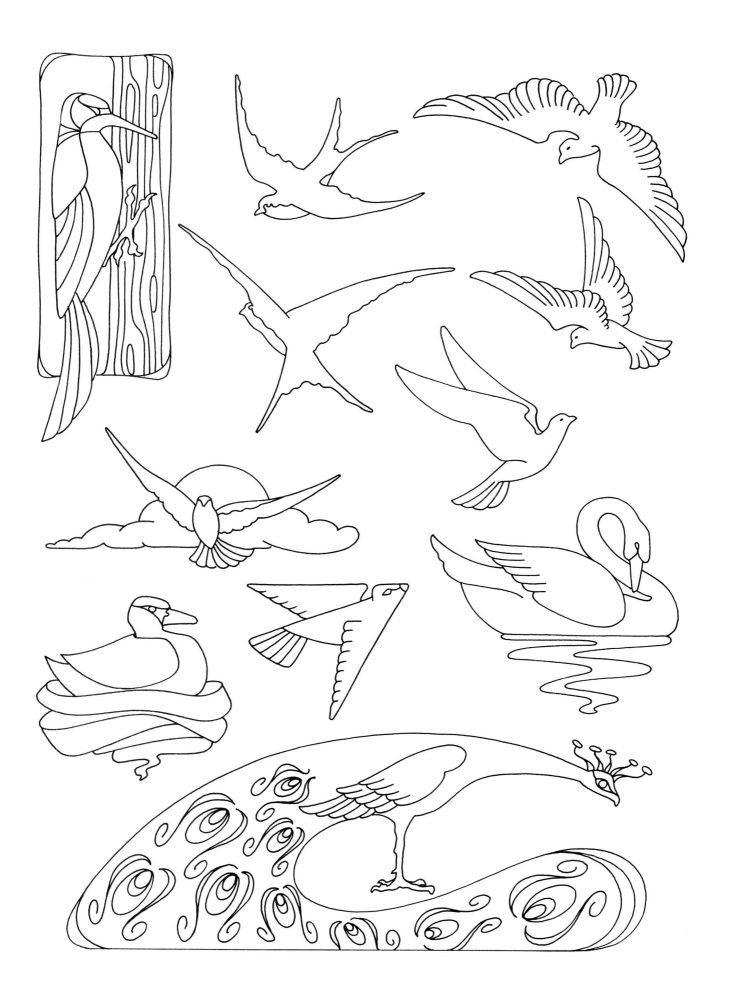

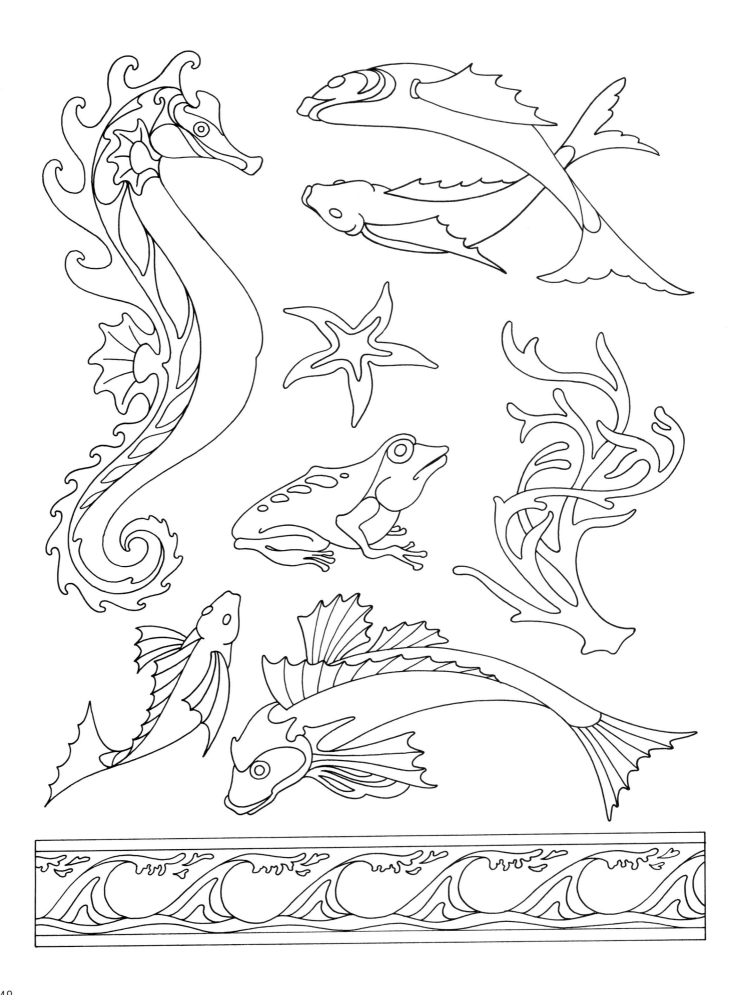

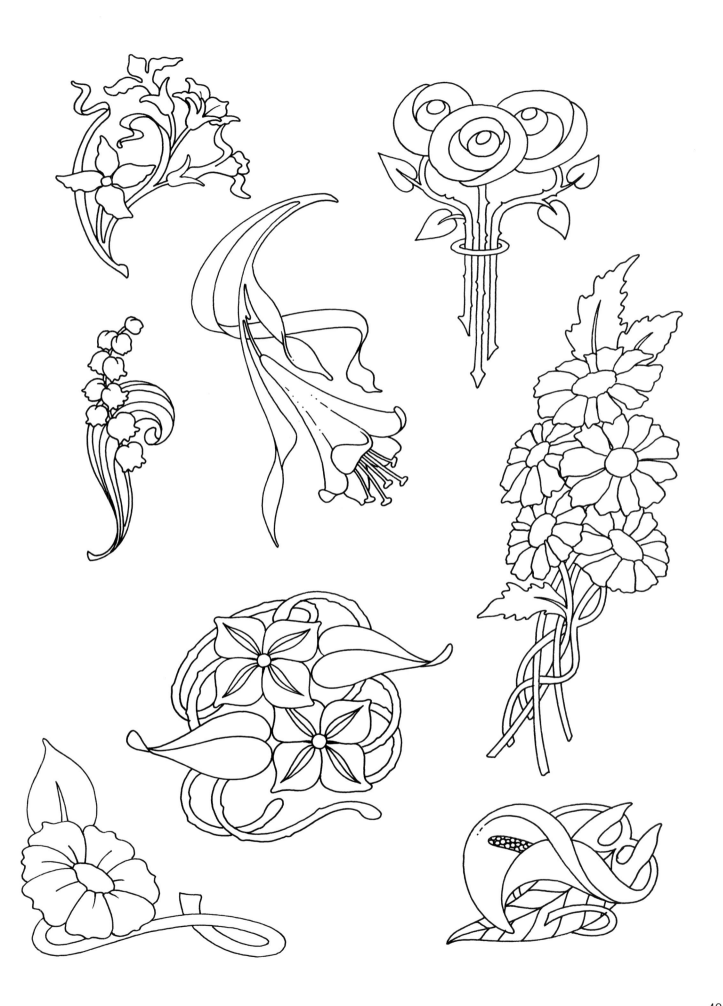

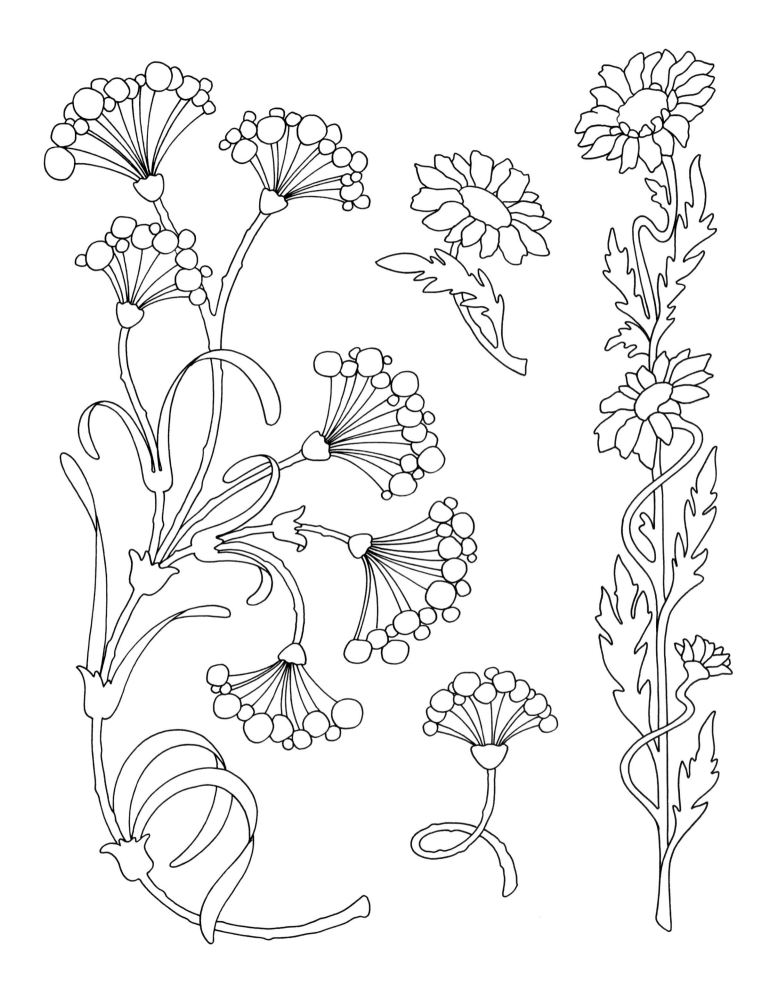

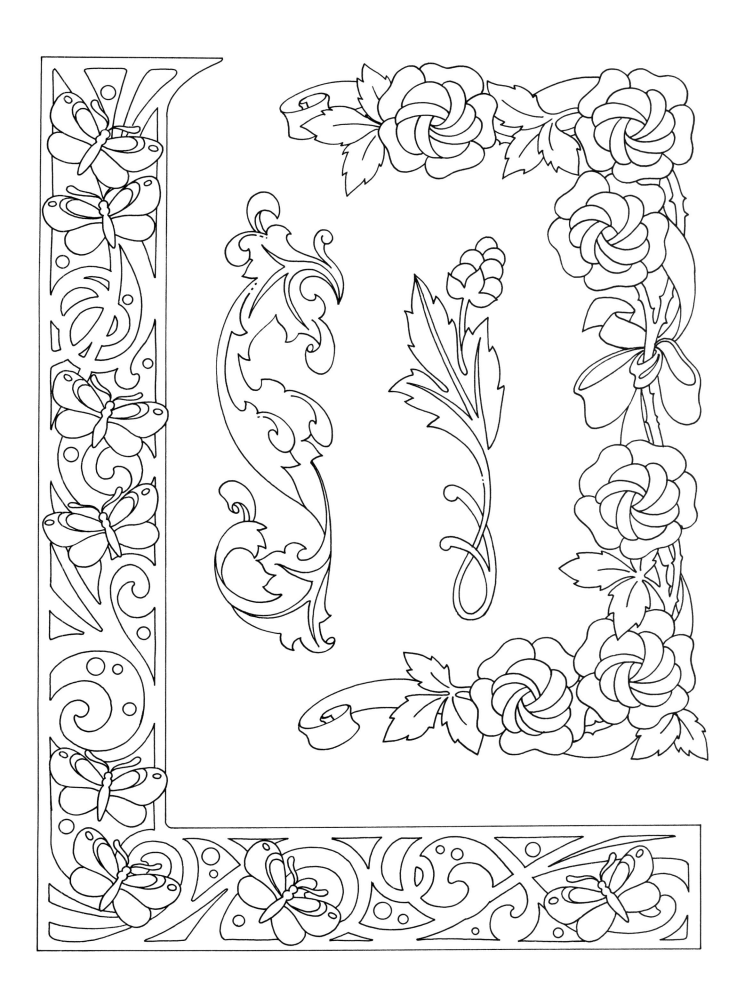

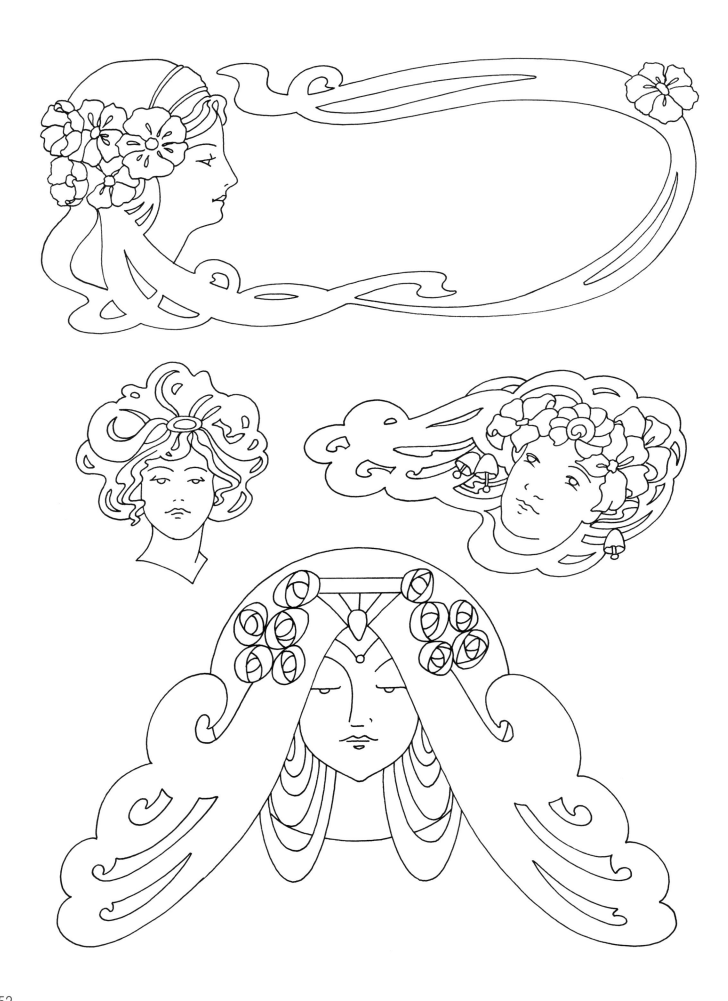

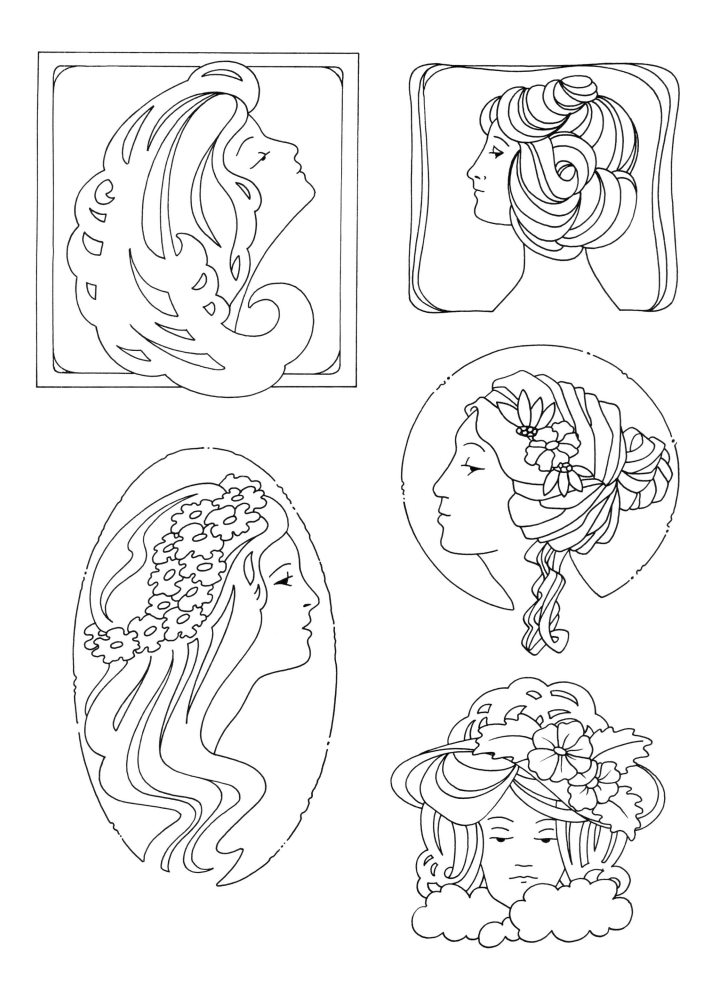

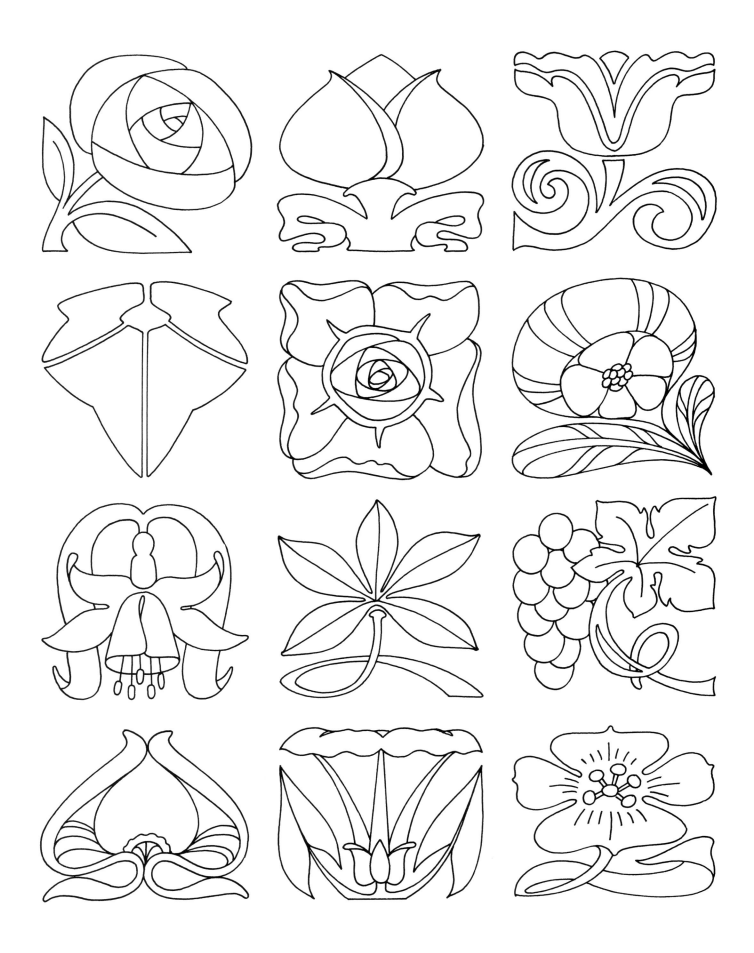

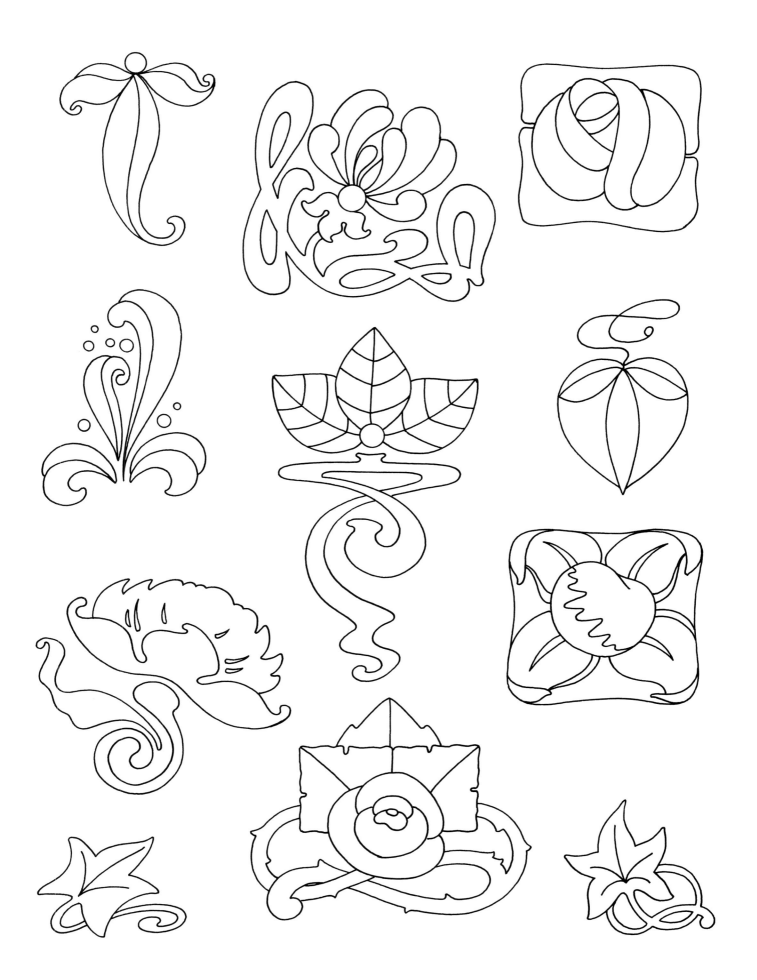

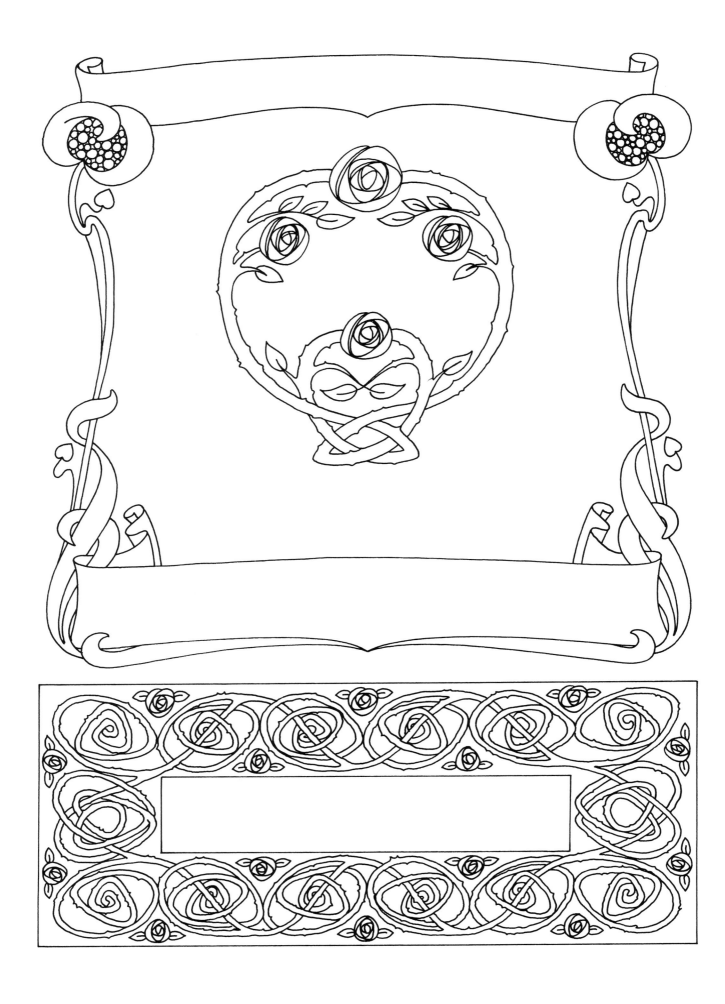

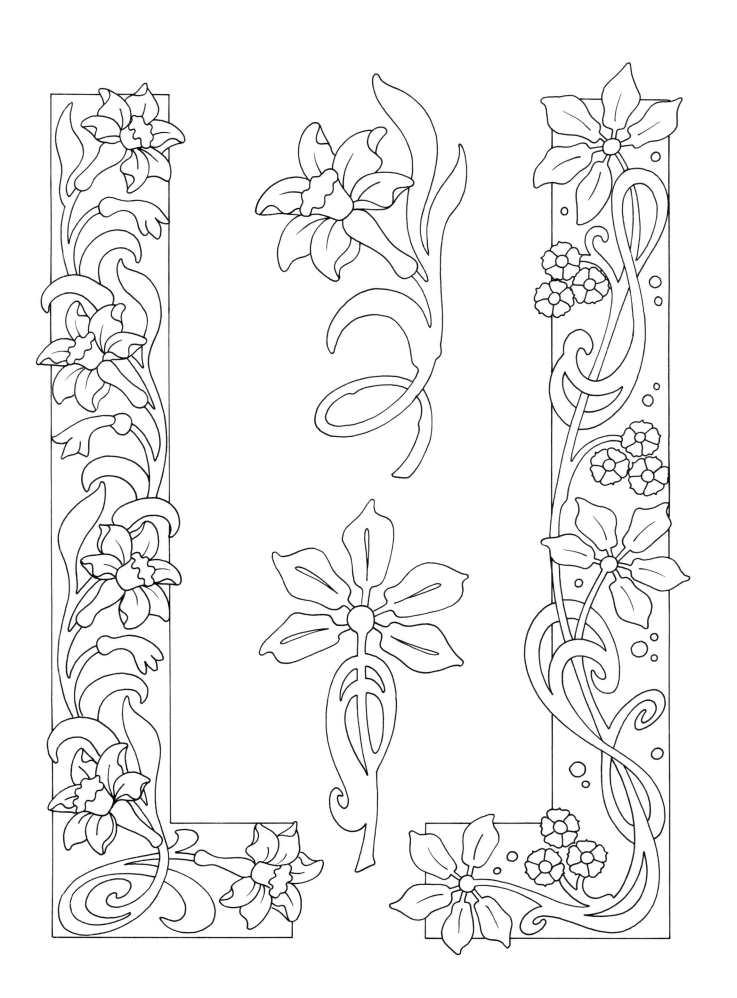

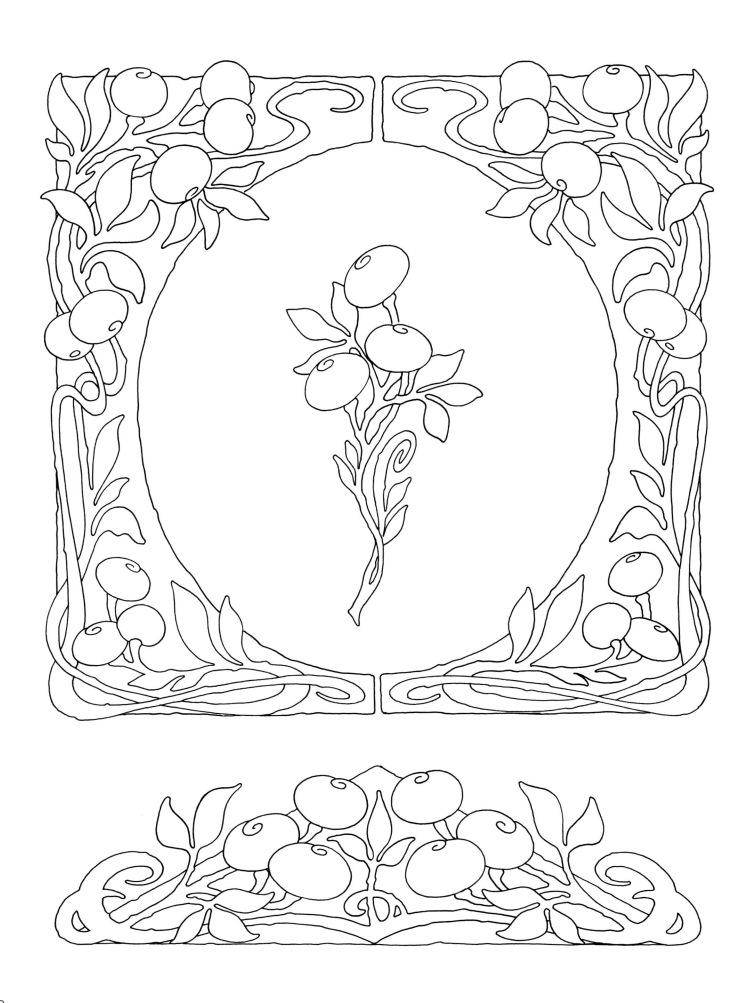

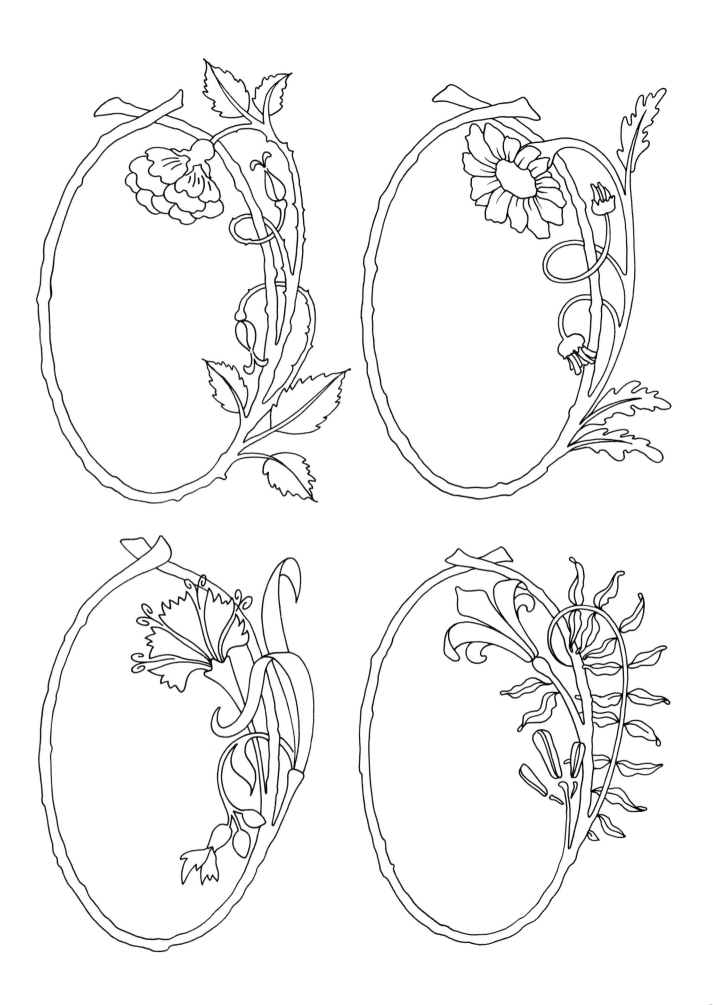

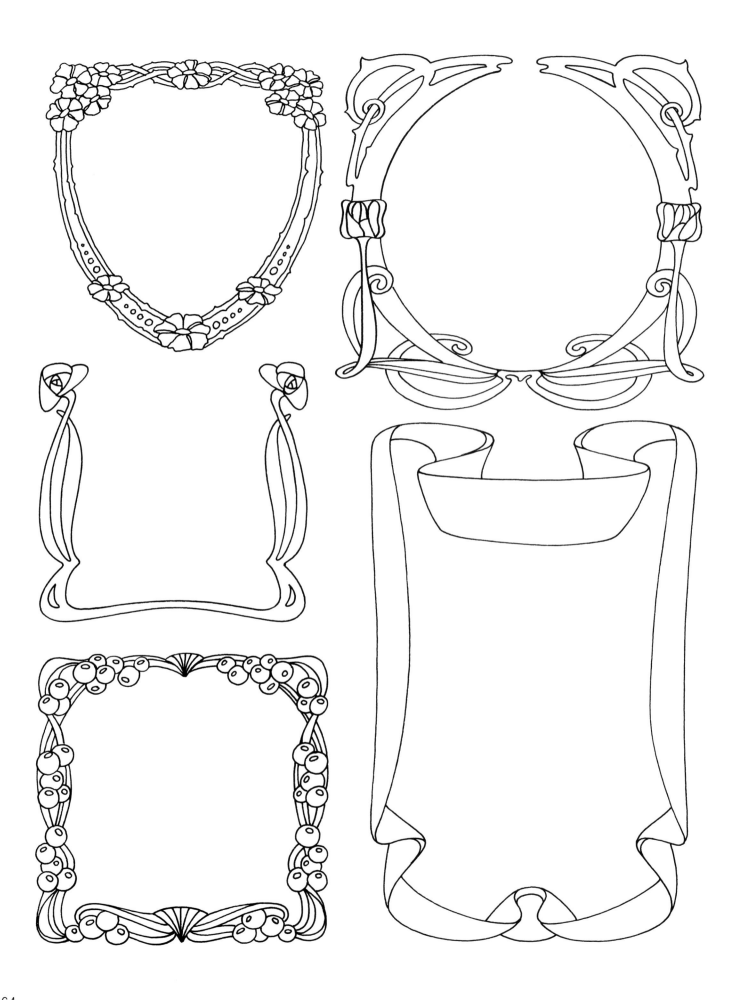

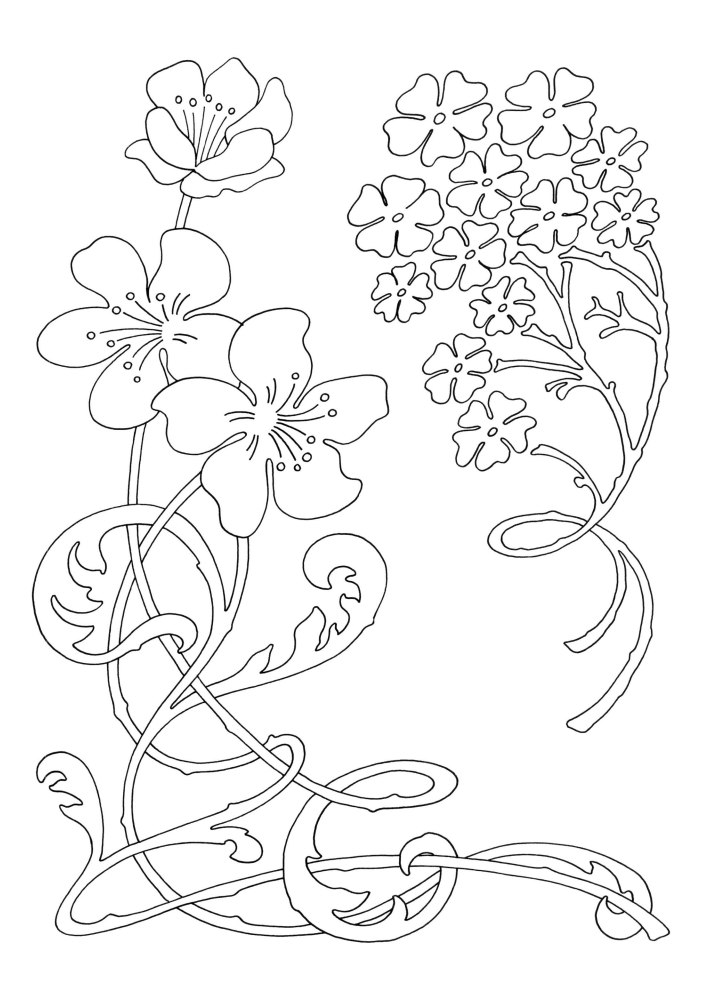

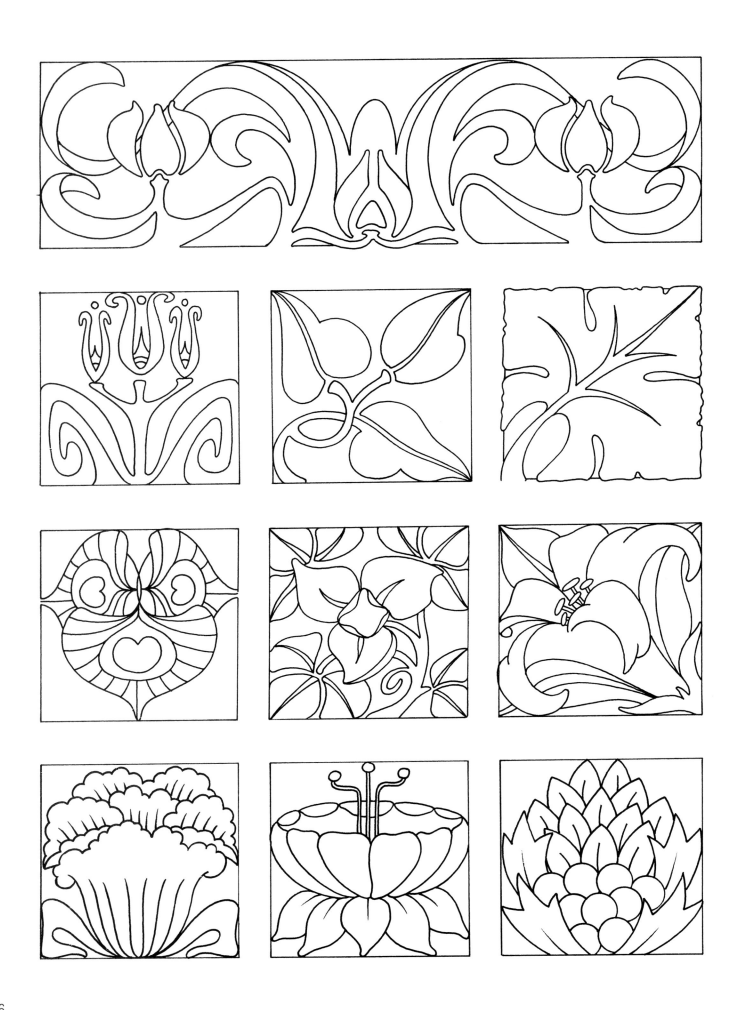

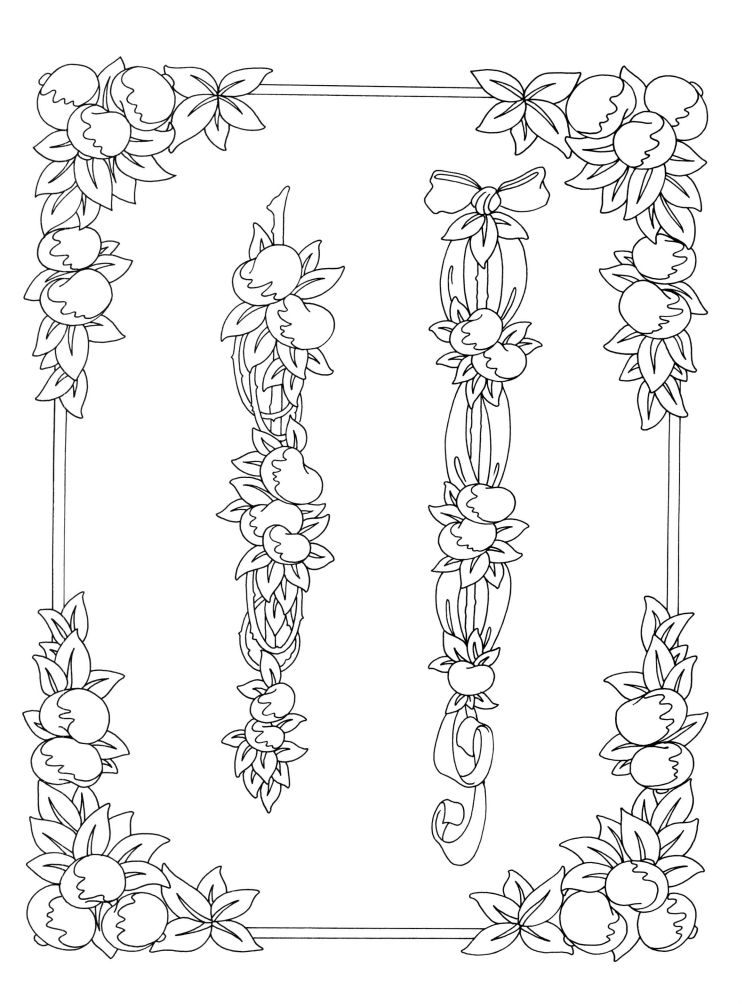

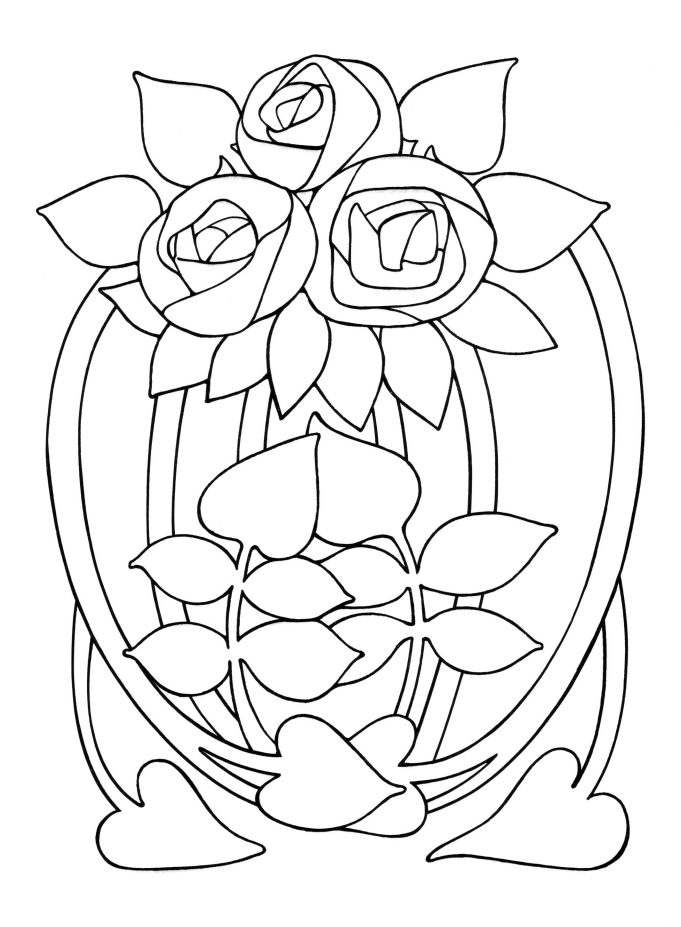

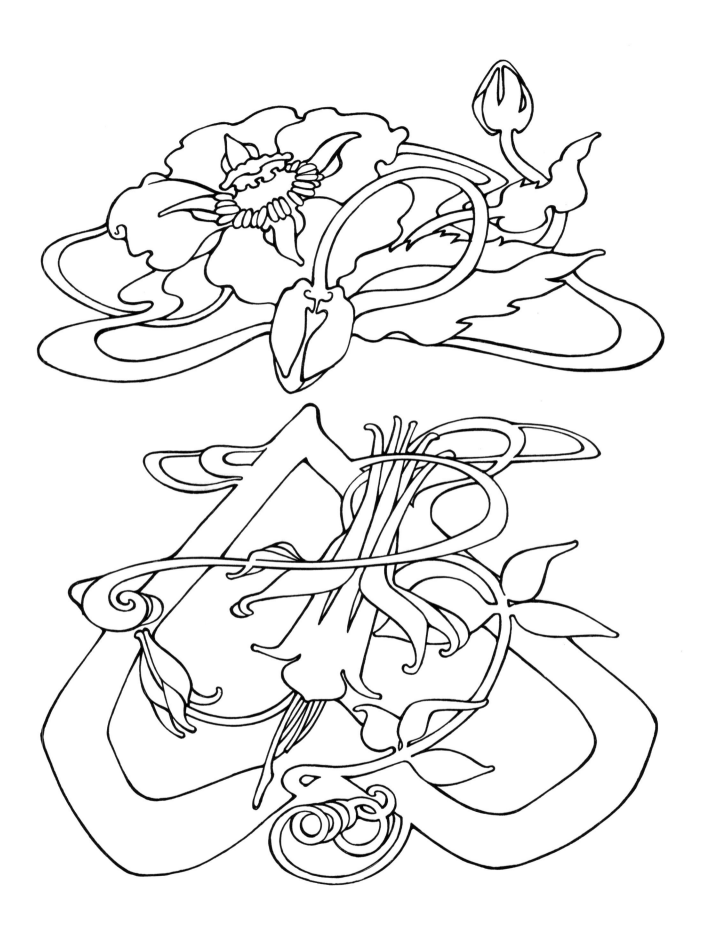

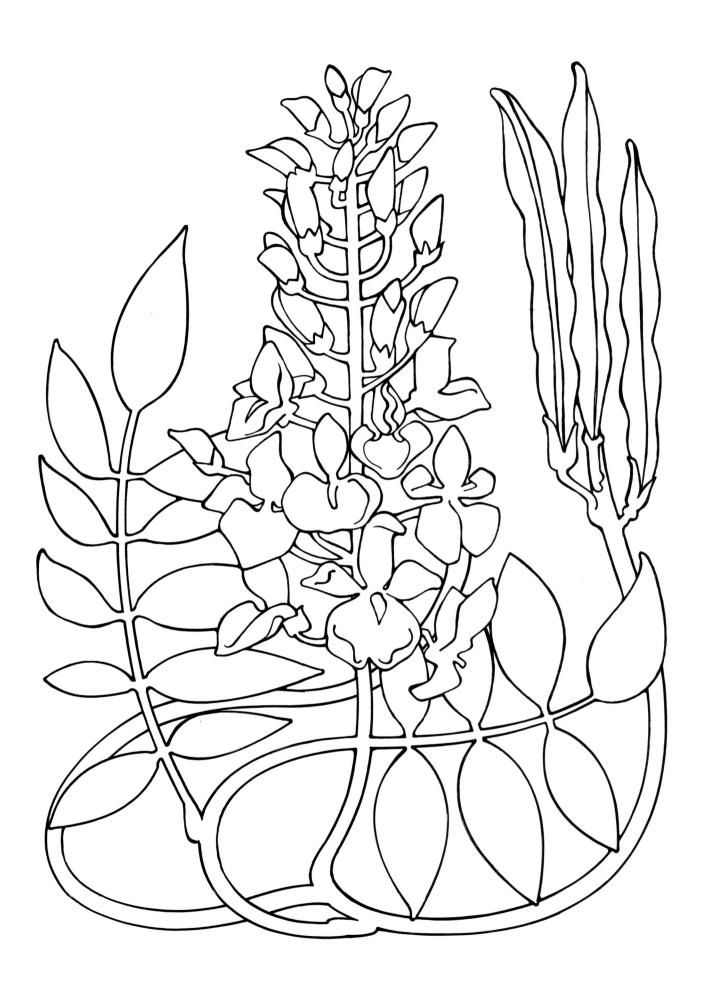

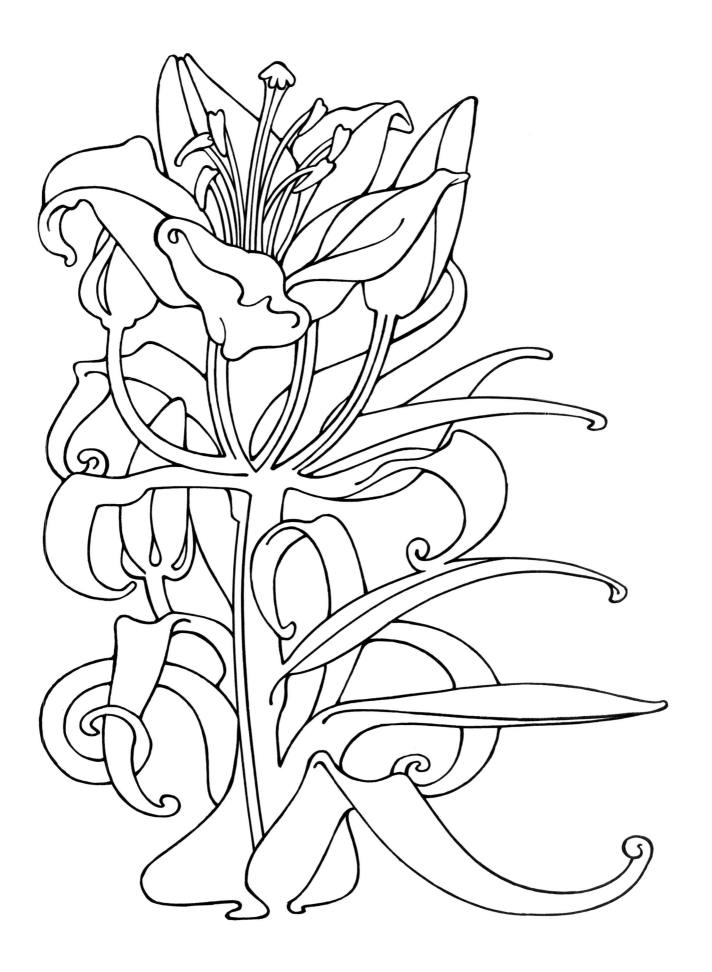

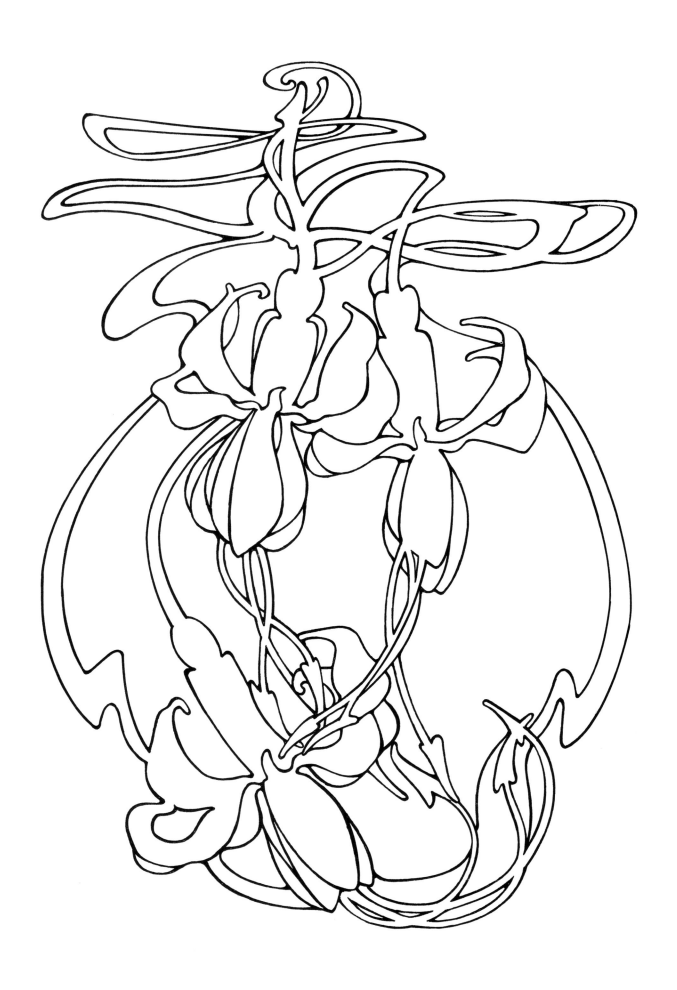

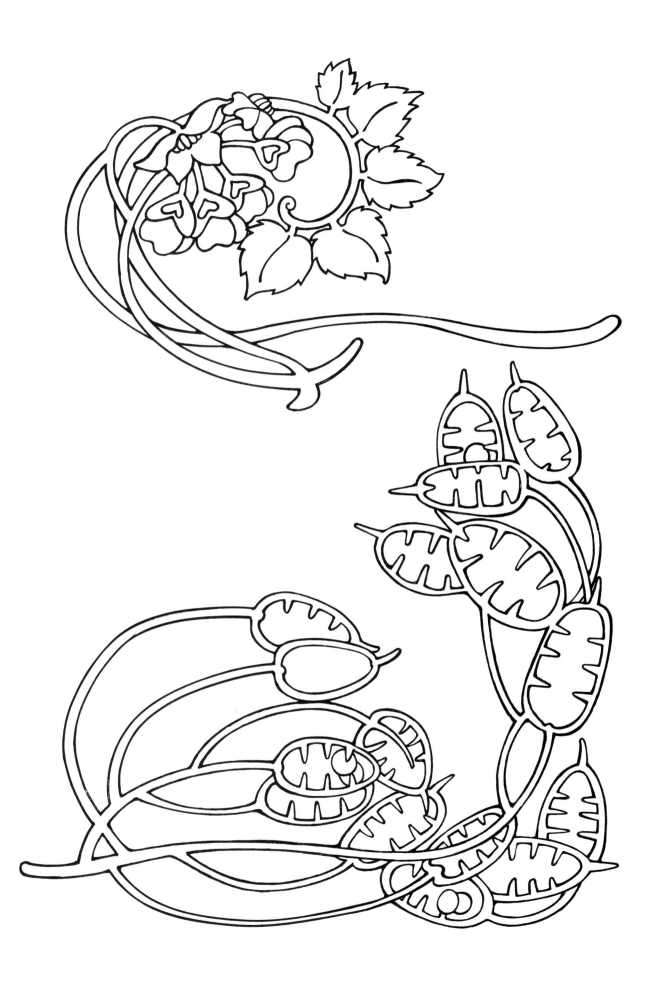

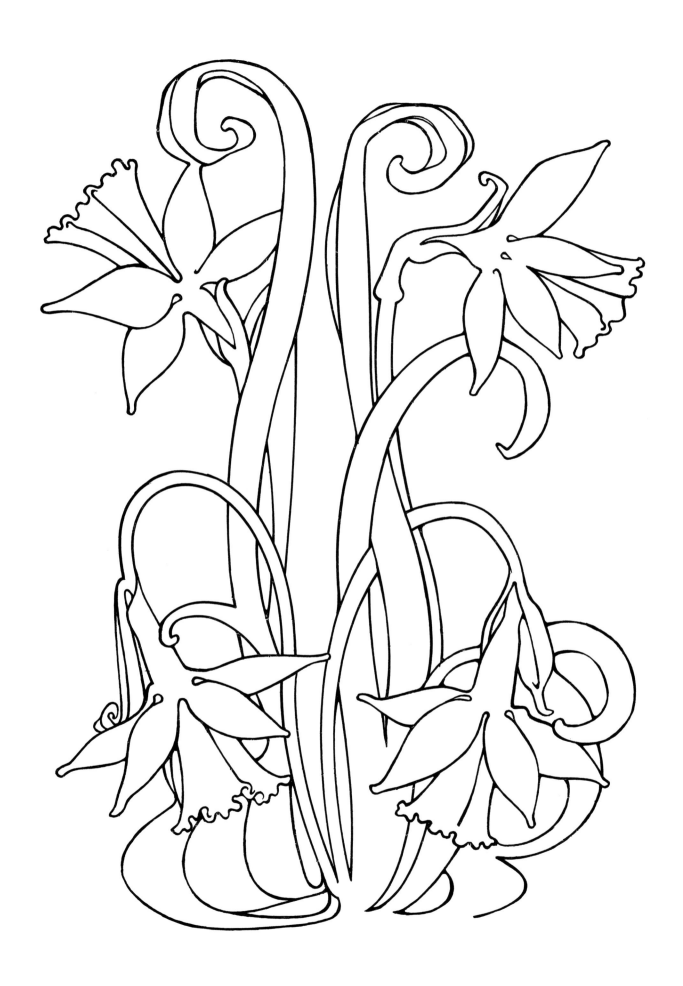

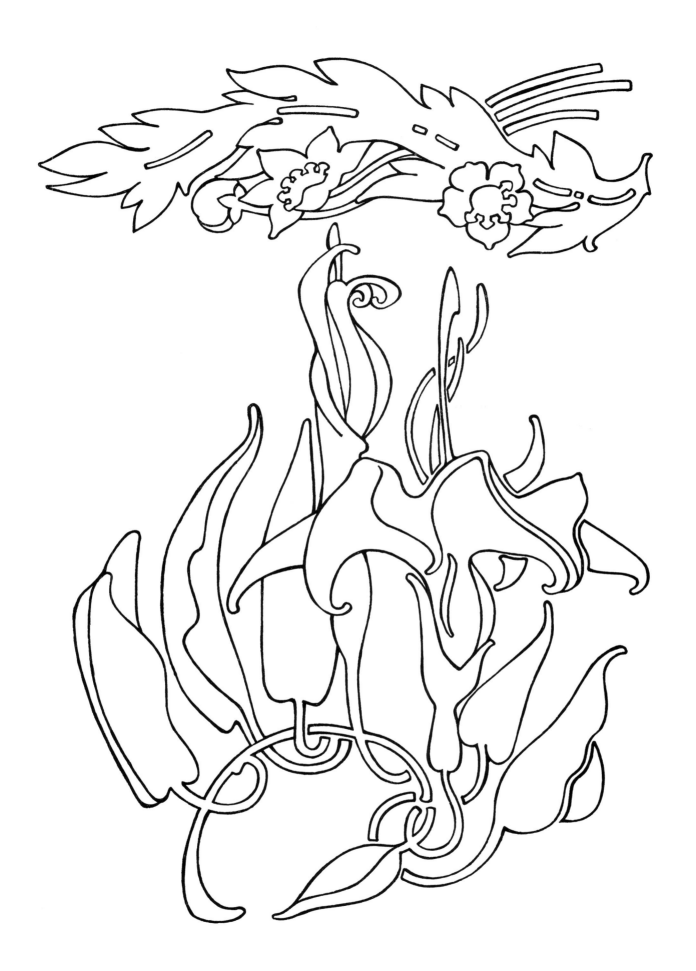

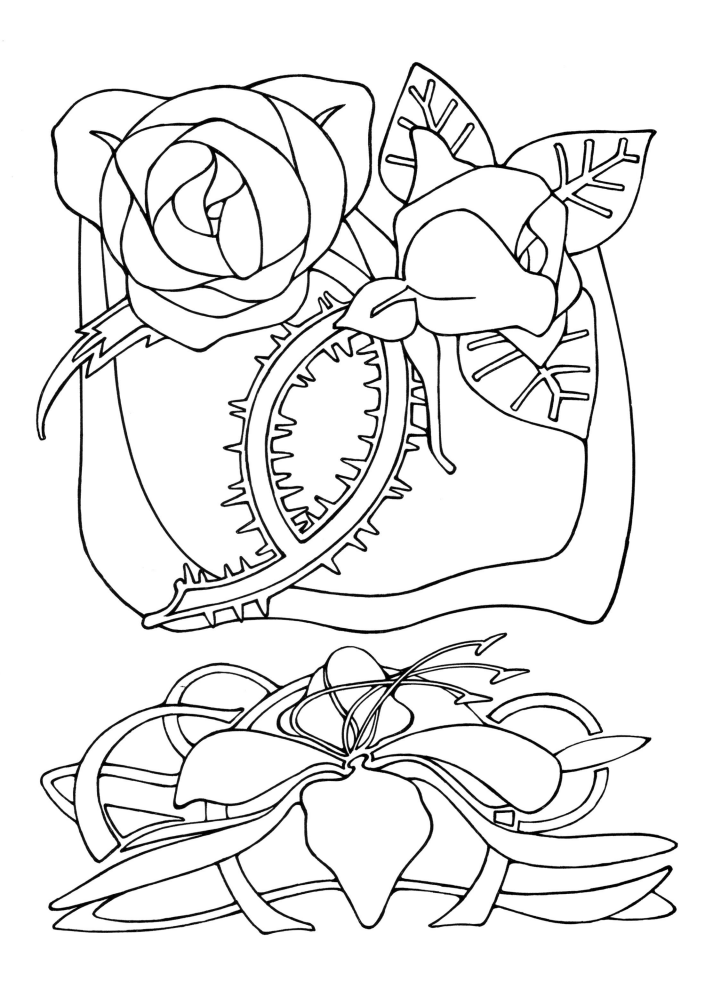

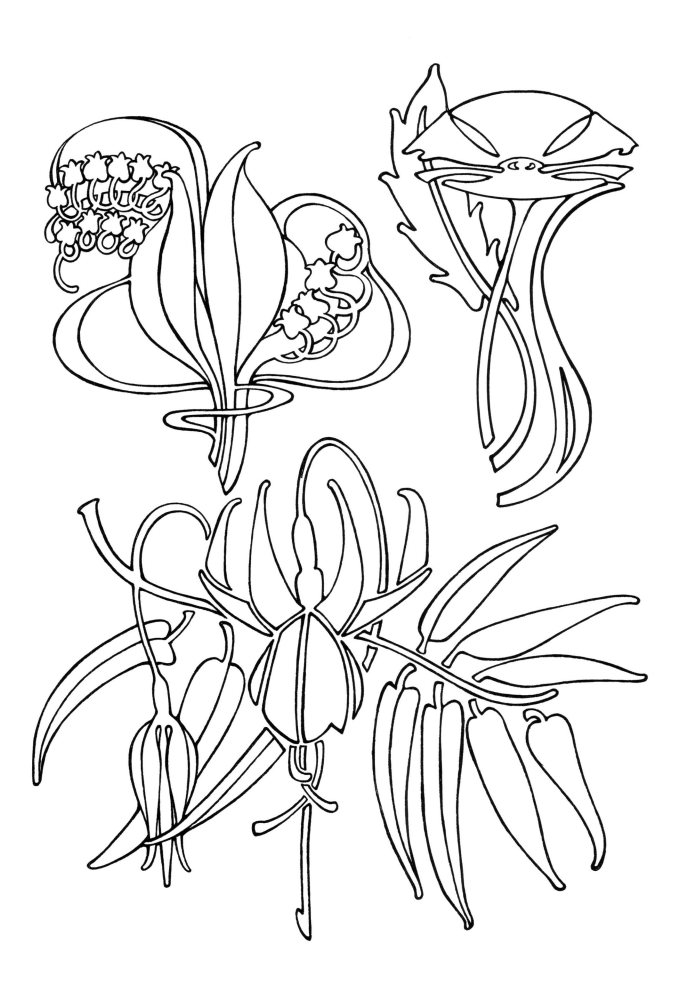

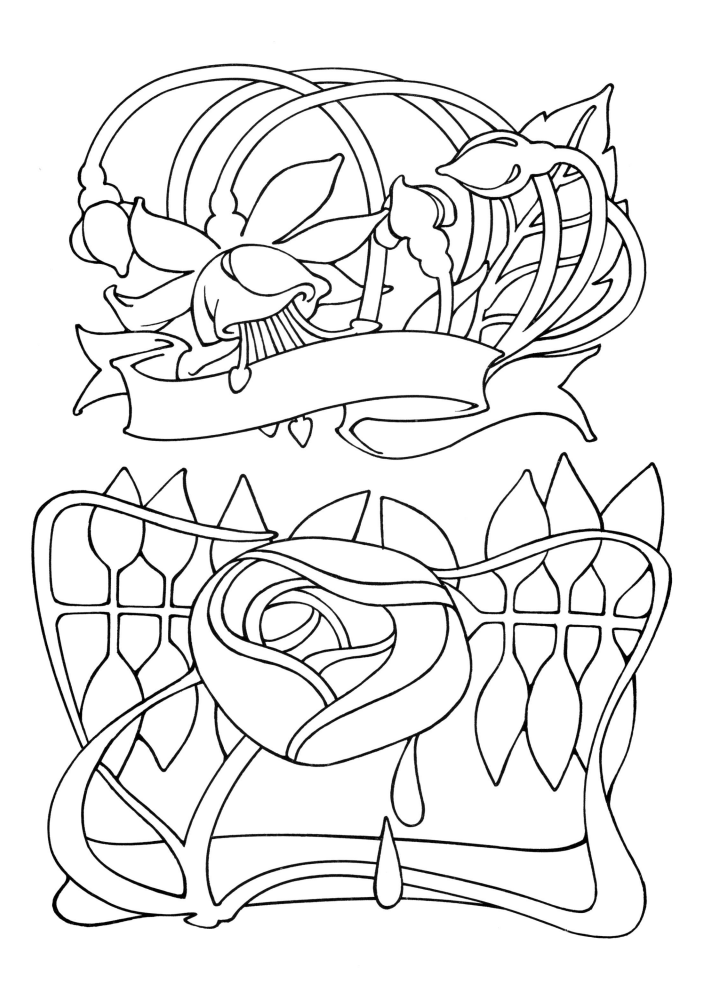

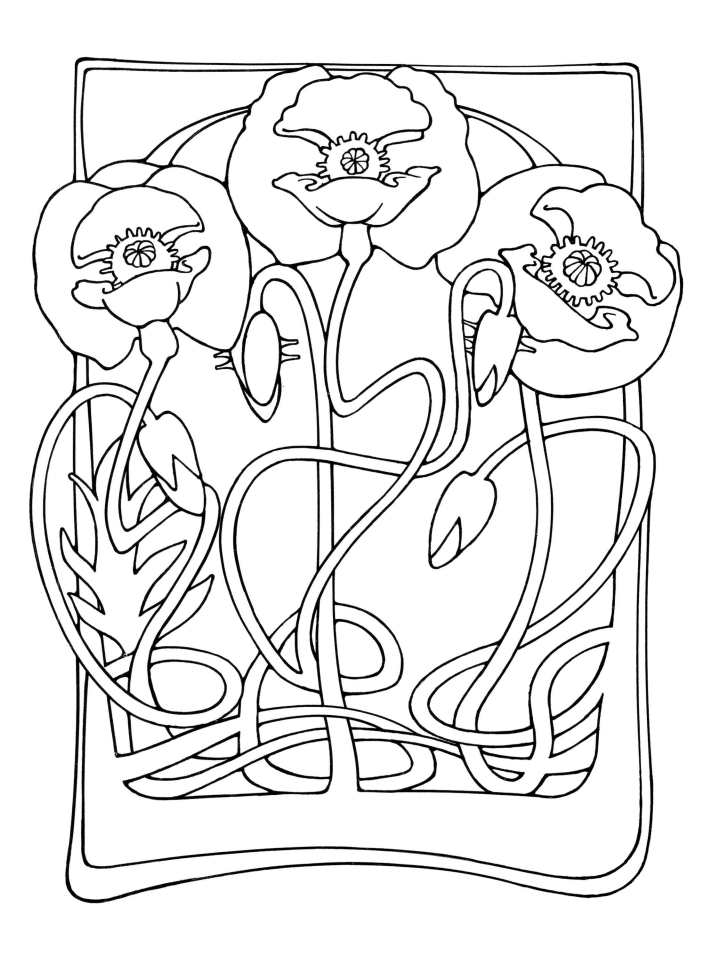

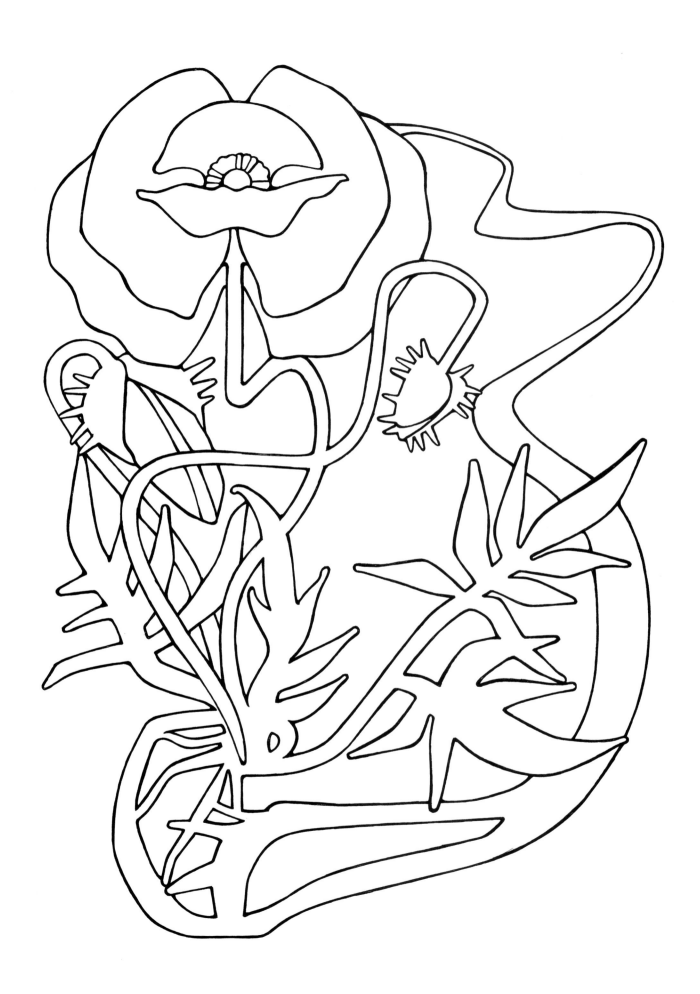

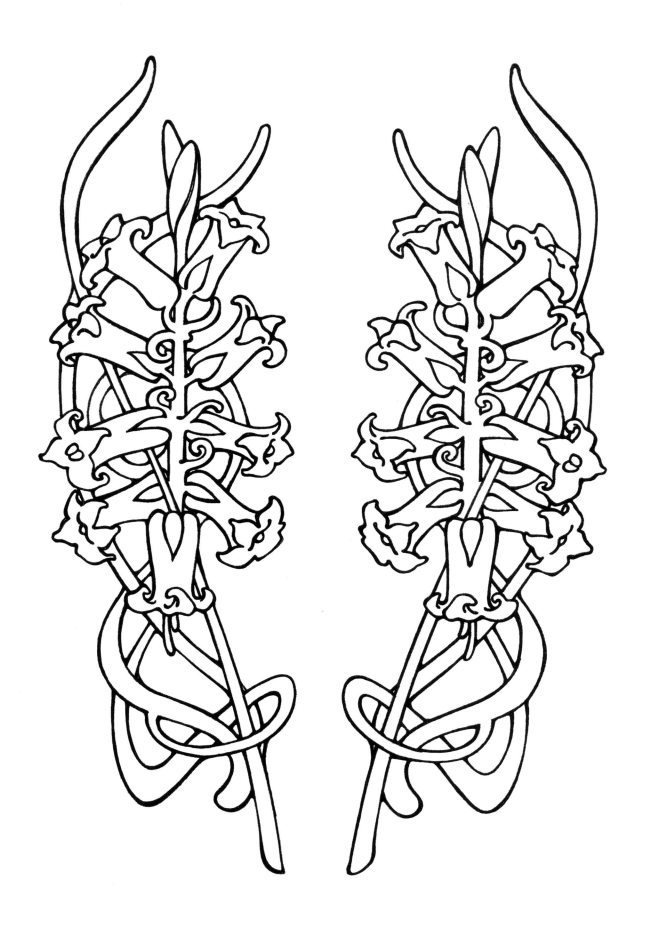

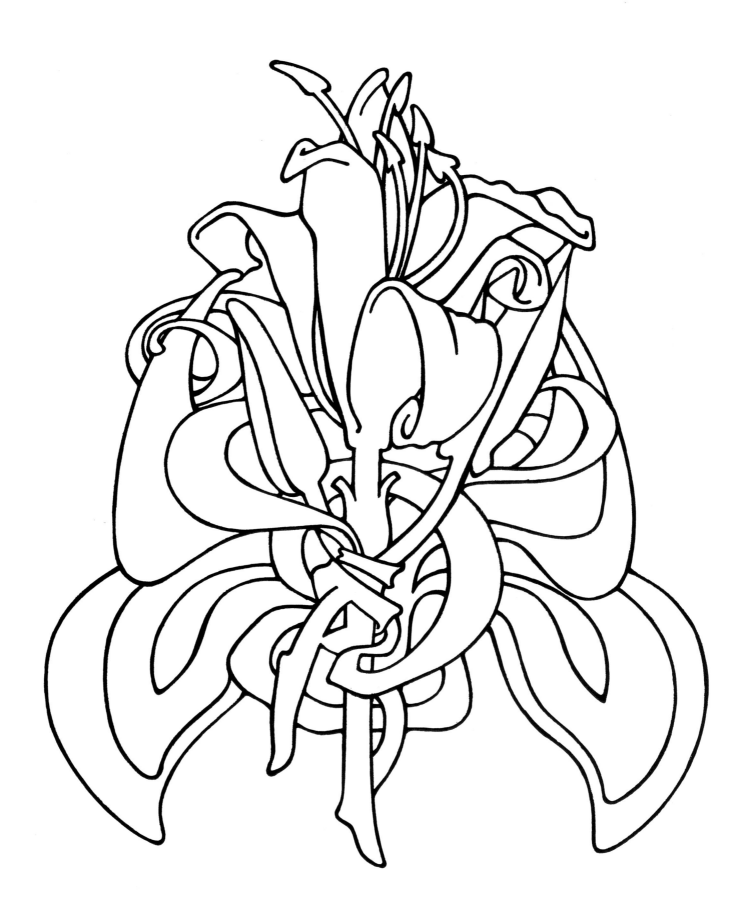

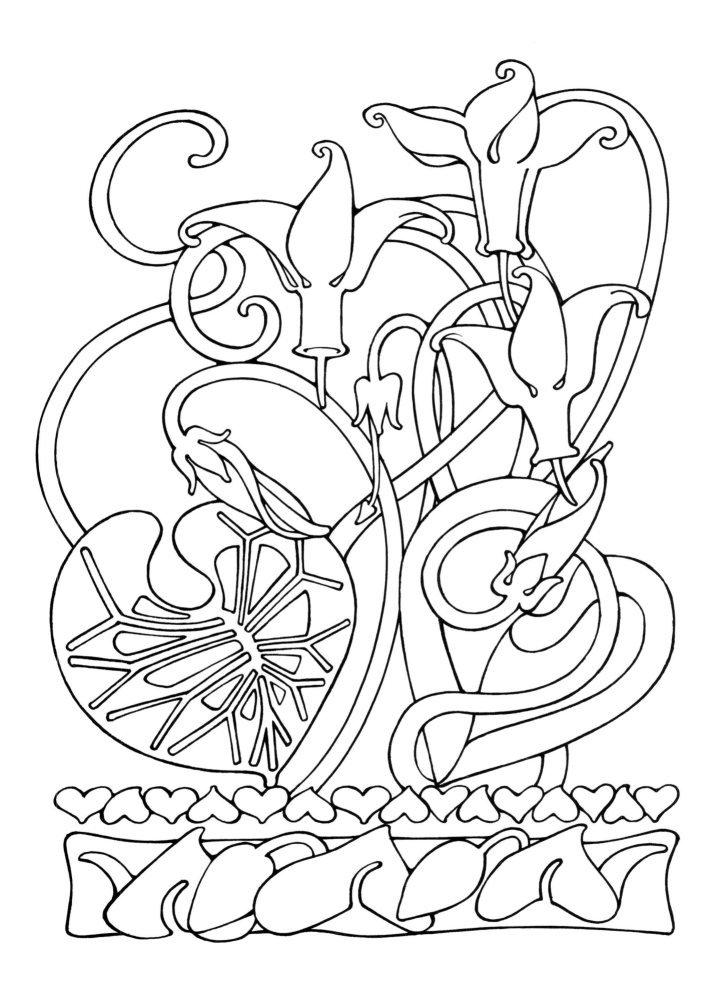

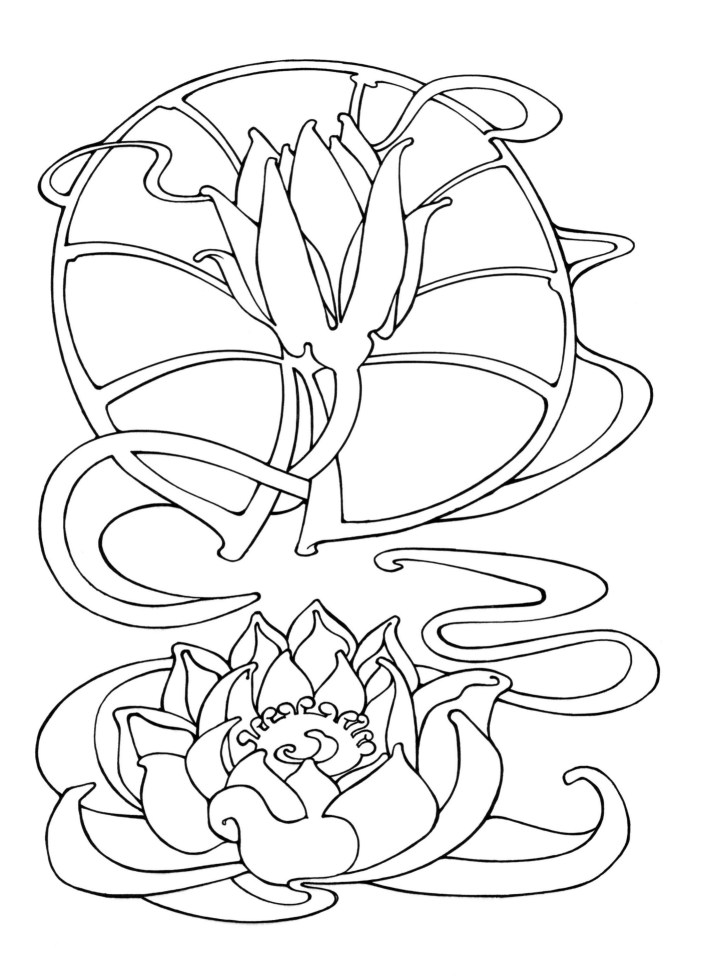

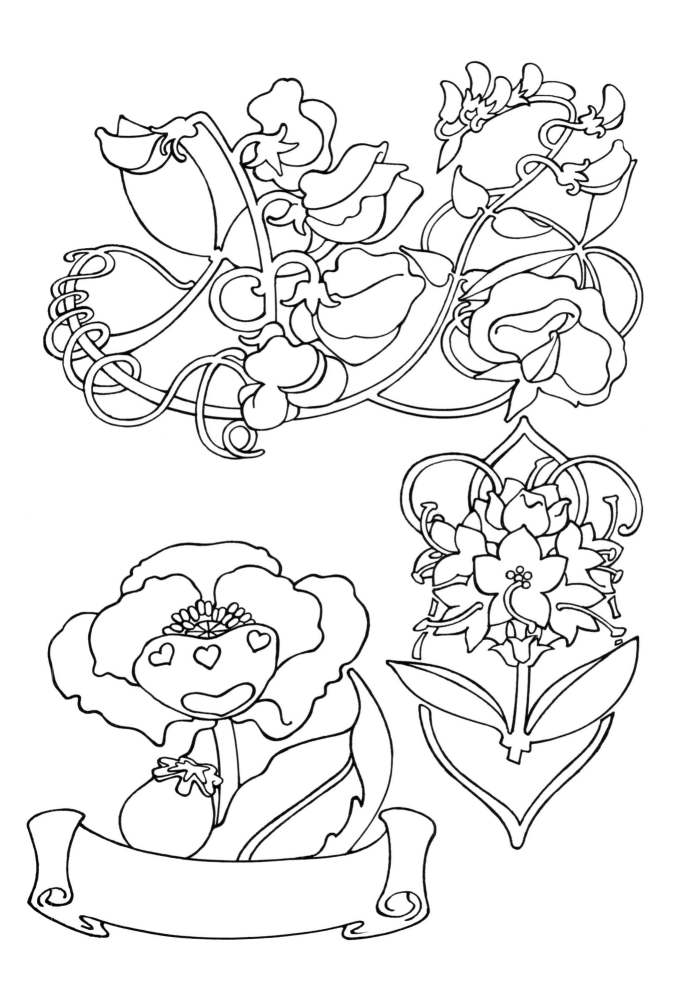

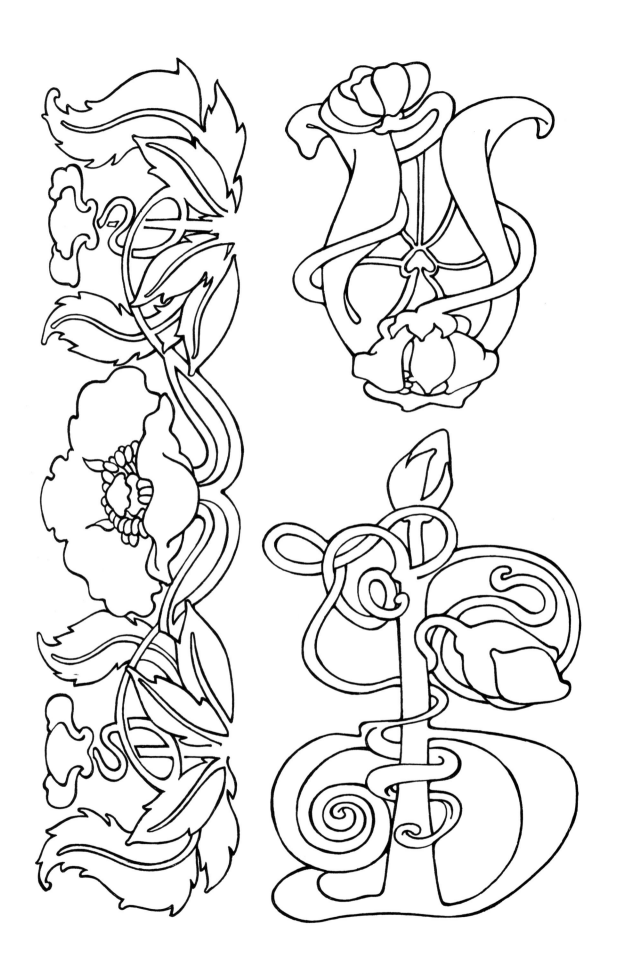

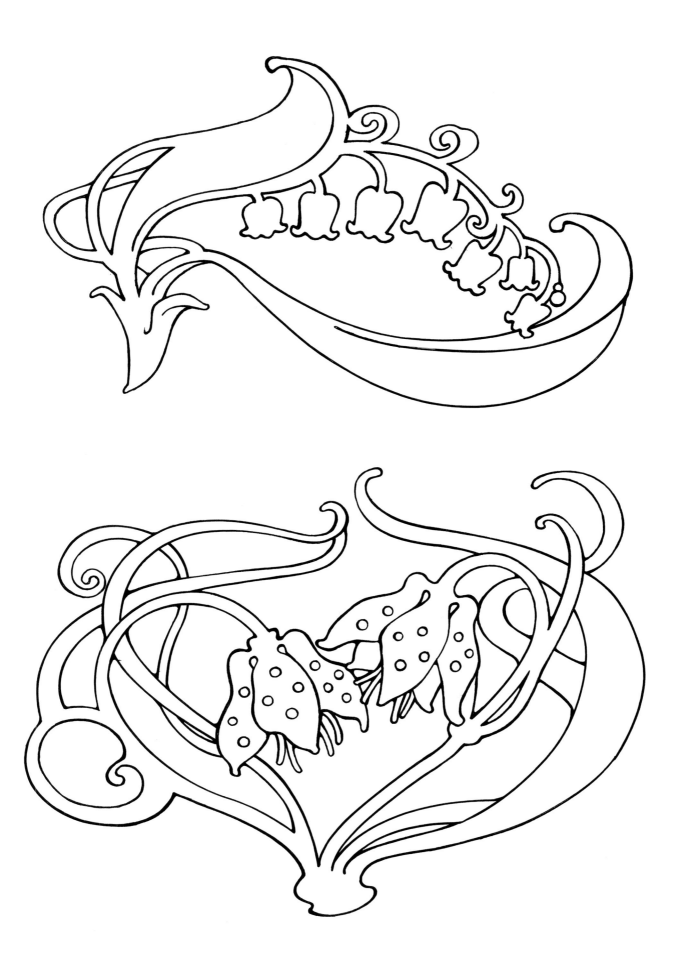

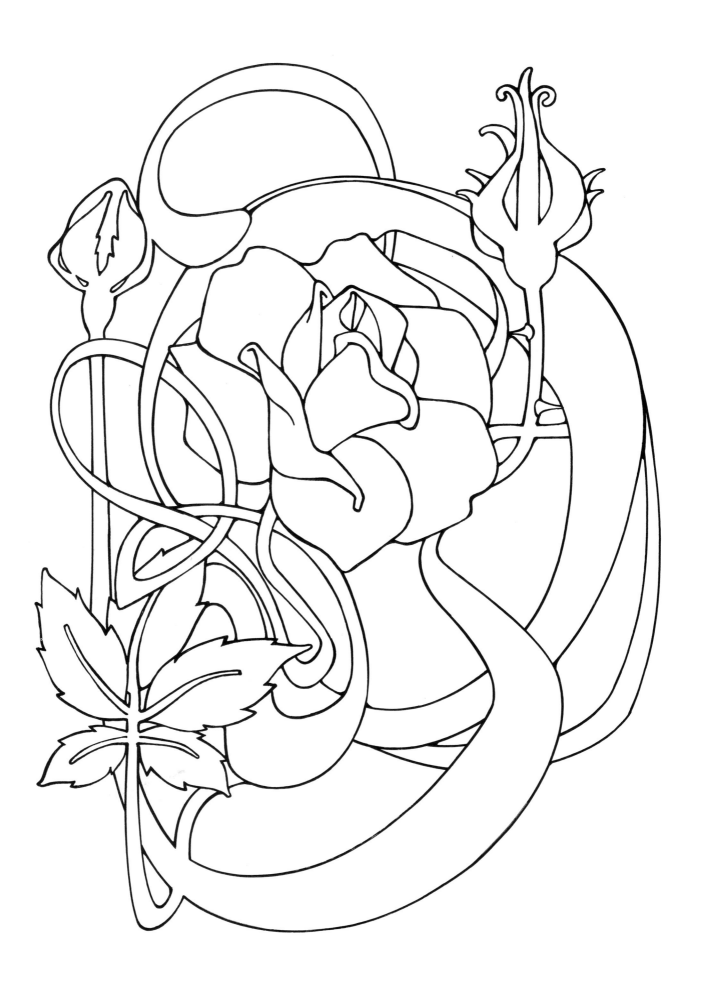

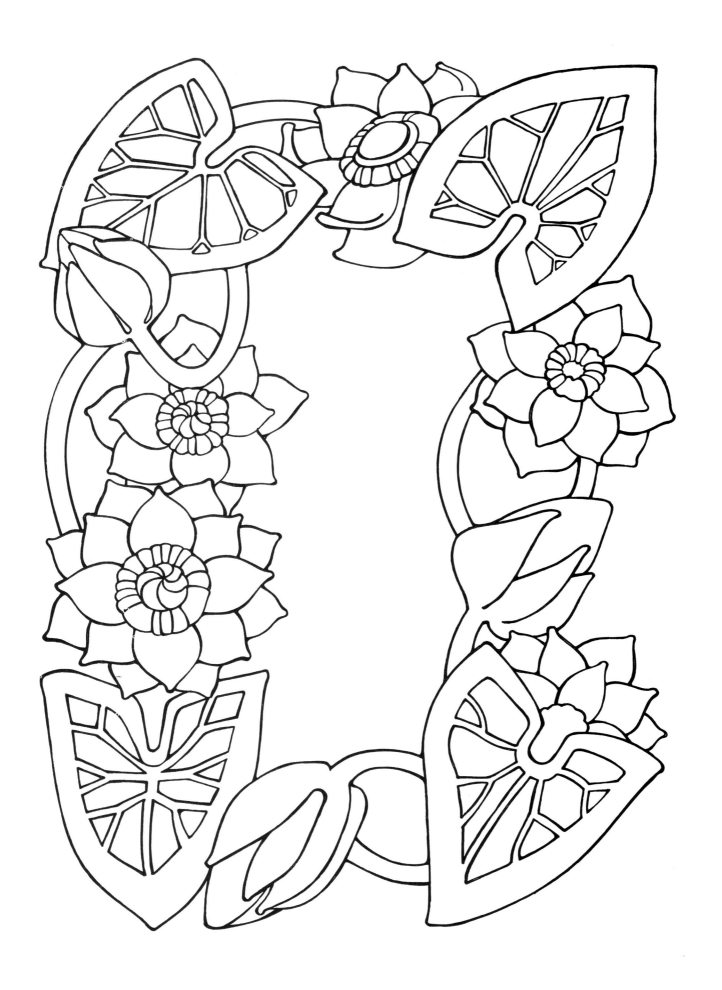

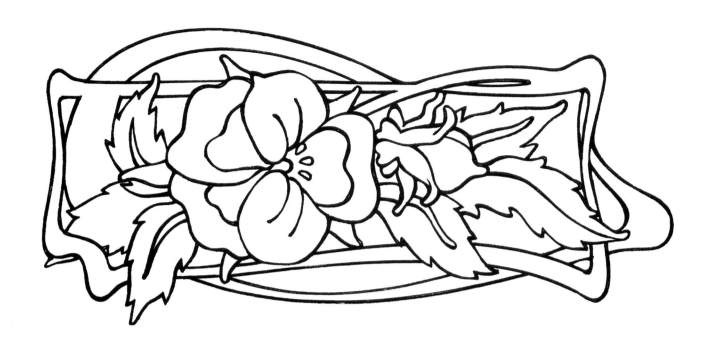

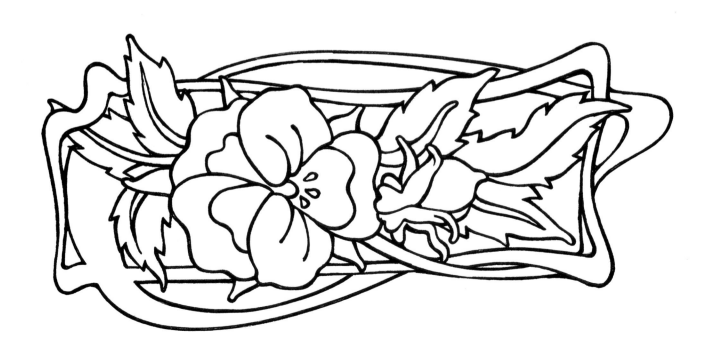

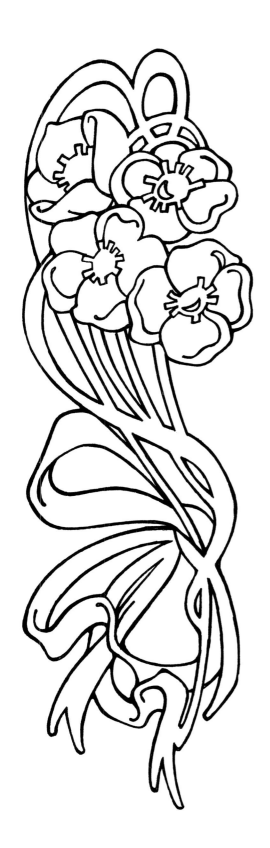
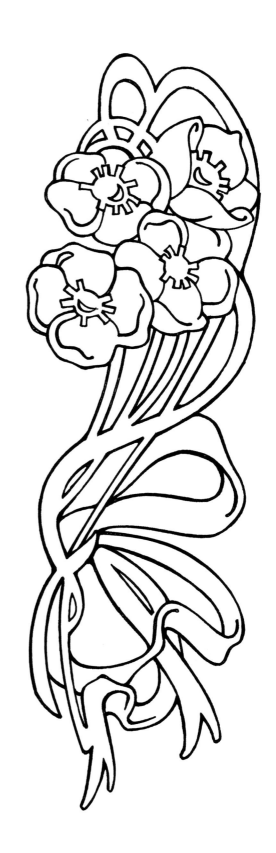

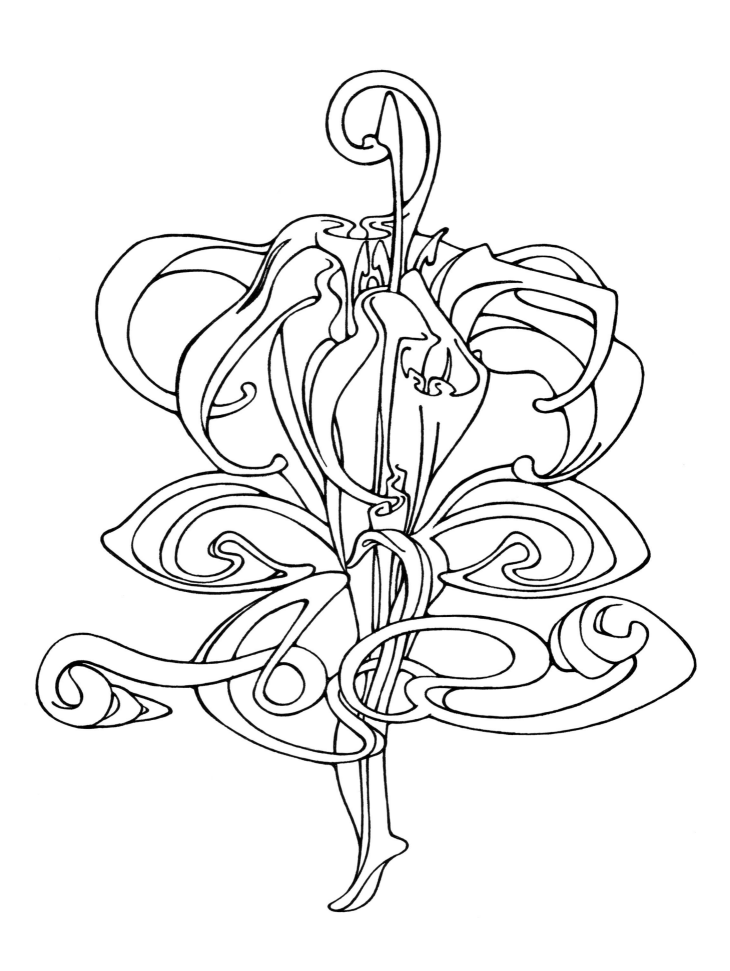

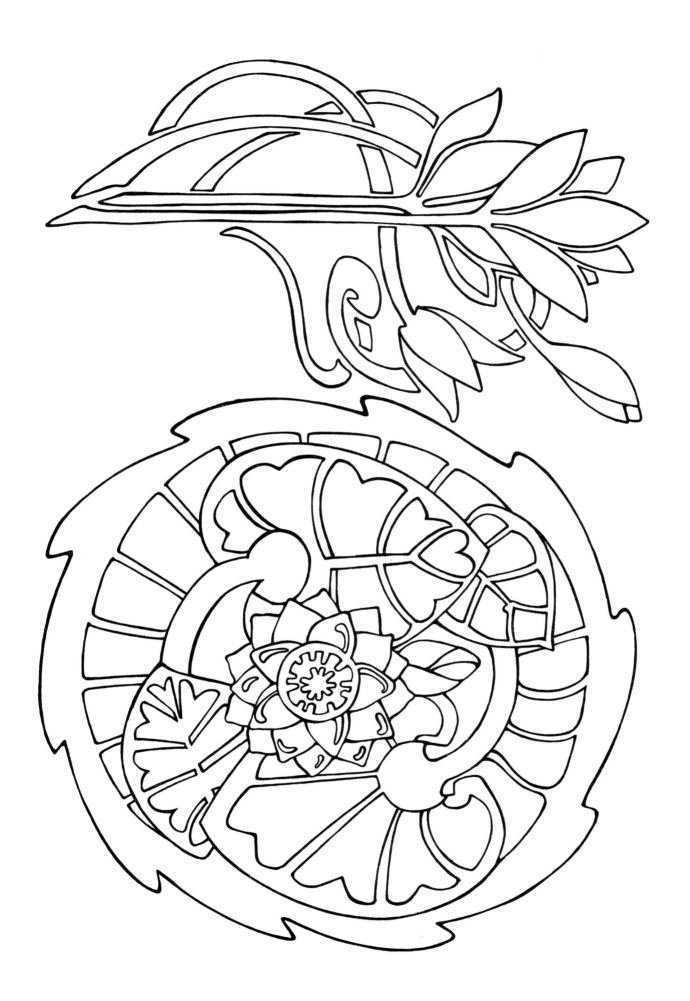

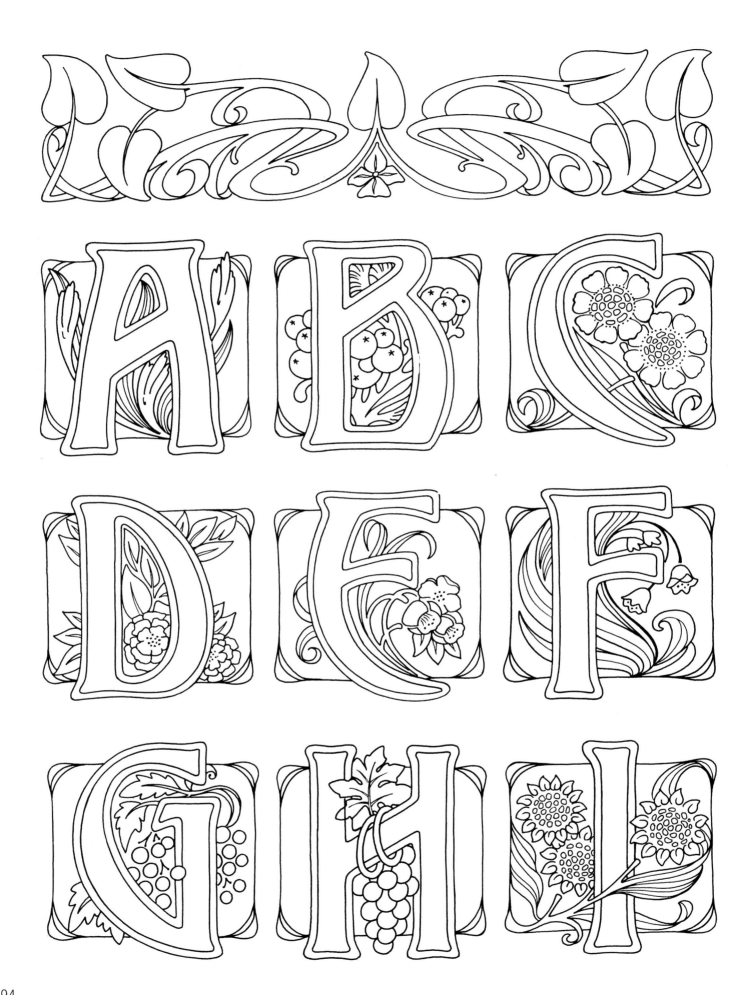

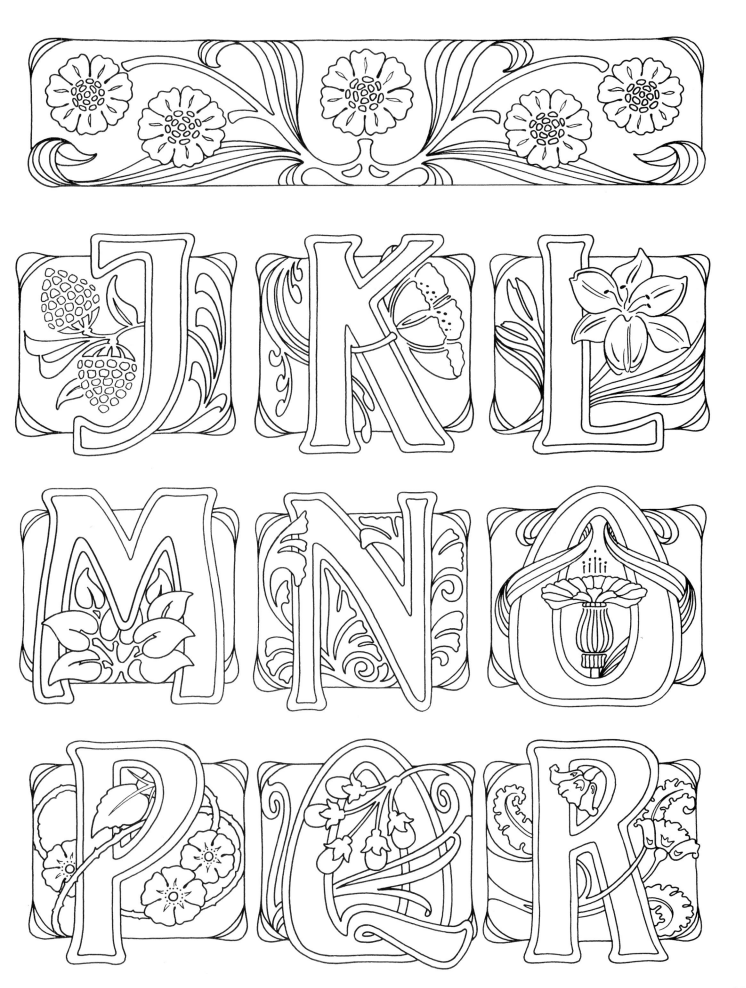

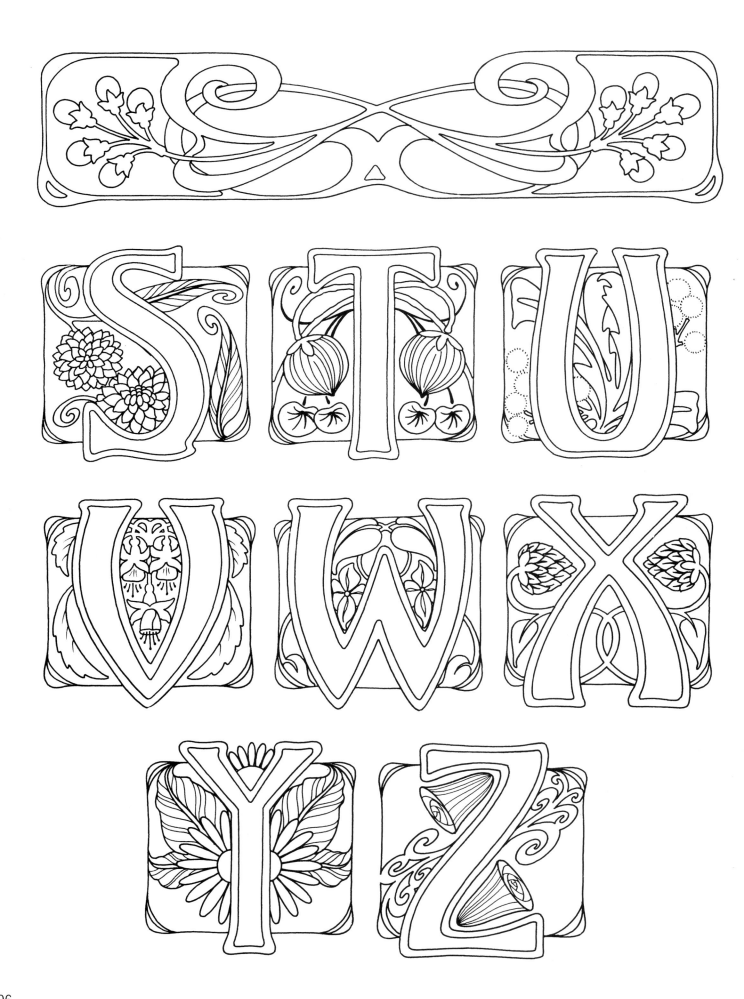